Tolkien
TREASURES

Tolkien

TREASURES

Catherine McIlwaine

Bodleian Library
UNIVERSITY OF OXFORD

First published in 2018 by the Bodleian Library
Broad Street, Oxford OX1 3BG
www.bodleianshop.co.uk

2nd impression 2018

ISBN: 978 1 85124 496 6

Production Editor: Susie Foster. Production: Nicola Denny. Designed
and typeset by Dot Little at the Bodleian Library in 9/13pt Warnock
Printed and bound in Italy by Graphicom on Gardamatt 150gsm. British
Library Catalogue in Publishing Data. A CIP record of this publication is
available from the British Library.

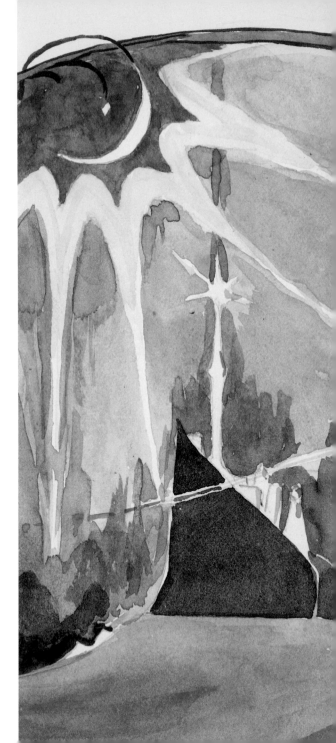

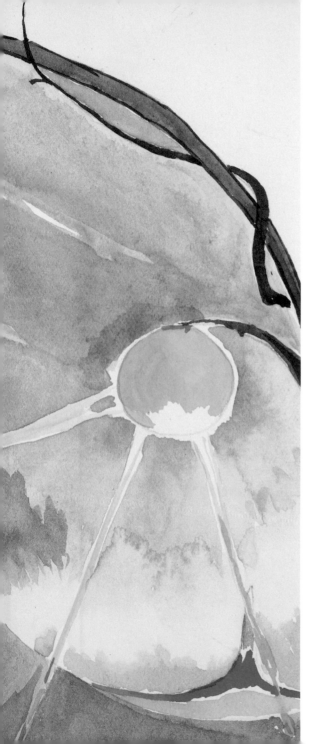

Contents

Timeline

1892	Born in Bloemfontein, Orange Free State
1894	Younger brother, Hilary Arthur Reuel Tolkien, born in Bloemfontein
1895	Arrives in England on an extended visit which subsequently becomes permanent
1896	Father, Arthur Reuel Tolkien, dies in Bloemfontein
1900	Attends King Edward VI School in Birmingham
1904	Mother, Mabel Tolkien, dies in Rednal near Birmingham
1909	Falls in love with Edith Bratt
1910	Forbidden by his guardian to have any contact with Edith for three years
1911	Matriculates at Exeter College, Oxford
1913	Reunited with Edith
1914	Britain declares war on Germany
1915	Graduates with First Class Honours; joins the Lancashire Fusiliers
1916	Marries Edith Bratt in Warwick; serves in northern France; invalided home
1917	First child, John Francis Reuel, born in Cheltenham
1919	Employed on the *Oxford English Dictionary*
1920	Appointed as Reader in English Language, University of Leeds; second child, Michael Hilary Reuel, born in Oxford
1922	*A Middle English Vocabulary* is published
1924	Appointed Professor of English Language, University of Leeds; third child, Christopher Reuel, born in Leeds

1925	Appointed Rawlinson and Bosworth Professor of Anglo-Saxon, University of Oxford; edition of the Middle English poem, *Sir Gawain and the Green Knight*, published, co-authored by E.V. Gordon
1929	Fourth child, Priscilla Mary Reuel, born in Oxford
1934	Article, 'Chaucer as a philologist' published
1937	Essay, 'Beowulf: the monsters and the critics' published; children's story *The Hobbit* published
1945	Short story, 'Leaf by Niggle' published; appointed Merton Professor of English Language and Literature, University of Oxford
1949	Comic story, *Farmer Giles of Ham*, published
1954–5	*The Lord of the Rings* published in three volumes
1959	Retires from academia
1962	Poetry collection, *The Adventures of Tom Bombadil* published; edition of the medieval text *Ancrene Wisse* published
1967	Fairy story *Smith of Wootton Major* published
1968	Moves to Poole in Dorset with his wife, Edith
1971	Edith dies in Bournemouth and is buried in Oxford
1972	Tolkien moves back to Oxford, occupying a Merton College property
1973	Dies in Bournemouth whilst visiting friends and is buried in Oxford, with his wife

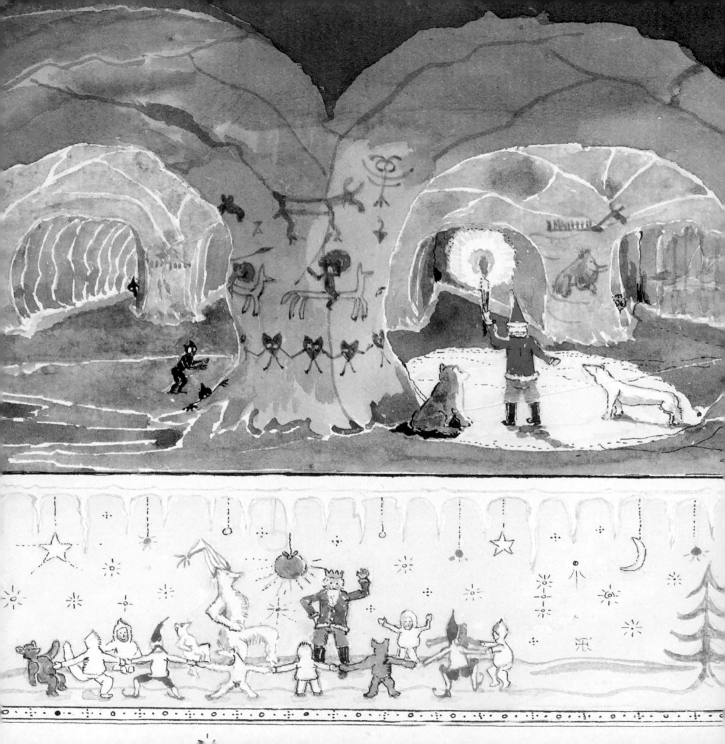

Introduction

J.R.R. Tolkien's fame rests today on his creation of Middle-earth and his bestselling fantasy work, *The Lord of the Rings*. Yet there were many facets to the man and his work. He was an internationally respected scholar of Old and Middle English. A philologist by profession and by nature, he not only studied languages but created his own. He was a visionary writer who filled his secondary world with languages and alphabets, peoples and creatures, myths and legends. He was also a talented artist and designer who illustrated his own works. Tolkien was a member of the literary coterie known as the Inklings, a group including C.S. Lewis, Owen Barfield and Charles Williams, which encouraged but perhaps hardly influenced his writing. Finally, he was also a devoted husband to Edith during their fifty-five-year marriage, and a loving father to four children. Tolkien had many demands on his time and many different roles to perform as a scholar, teacher, author, artist, friend, father and husband, but these separate parts all contributed to a unique imagination and expression of thought which resulted in the creation of the legends of Middle-earth.

First and foremost, Tolkien was a philologist; his interests lay in language and the roots of language. For over forty years he studied and taught the languages that lay behind Modern English, tracing its roots through Middle English and Old English to the Germanic languages of north-western Europe. On this journey he encountered and thought deeply about the associated literature, peoples, histories and legends. In a very real sense these professional interests also lay behind his literary work. 'The authorities of the university might well consider it an aberration of an elderly professor of philology to write and publish fairy-stories,' he wrote, 'but it is not a "hobby", in the sense of something quite different from one's work.'[1] In Tolkien's mind the creation of Middle-earth and the study of Middle English were closely connected. His professional academic work and his private literary work stemmed from the same impulse – the exploration of language. The foundation of his whole legendarium was language, or more precisely the invention of language. He derived pleasure from creating languages; from combining sound, word-form and meaning into a harmonious whole, and from these languages sprang people, histories, legends and stories.

Tolkien had invented languages since he was a child, sometimes alone and sometimes with his cousins, Mary and Marjorie Incledon, who invented their own rudimentary language, 'Animalic'. From an early age he was interested in the building blocks of language rather than literature. In a letter to the poet, W.H. Auden, he

wrote, 'I first tried to write a story when I was about seven. It was about a dragon. I remember nothing about it except a philological fact. My mother said nothing about the dragon, but pointed out that one could not say "a green great dragon", but had to say "a great green dragon". I wondered why, and still do … I do not think I ever tried to write a story again for many years, and was taken up with language.'[2] There are many points of interest in this recollection but perhaps the most important is that he 'was taken up with language'. It was this fascination with the mechanics and development of languages that led him to study Anglo-Saxon and Gothic in his spare time as a schoolboy, and to try to teach himself Finnish as an undergraduate when he should have been studying Latin and Greek. After two years at university he was allowed to change his course from Classics to English so that he could specialize in Old Norse, Old English and Middle English, exploring the history and development of the English language. During the next three years he began to create the two Elvish languages that would become Quenya and Sindarin. These languages encompassed grammatical structures and sounds which were pleasing to him personally. The two languages were related but each had its own distinct flavour: one strongly influenced by Finnish and the other by Welsh. Tolkien soon came to the conclusion that no matter how pleasing these languages were, without legends and stories, and without their own mythological background, they were sterile and could have no real life of their own. This realization led him back from language to literature: to the creation of myths and legends for his Elvish speakers. It was the beginning of what was to become his life's work – 'The Silmarillion'.

After finishing university he determined to make language his life. Having survived the First World War, he worked for a brief period at the *Oxford English Dictionary* defining words, before taking up academic positions first at the University of Leeds and then at Oxford, studying and teaching Old and Middle English, Gothic, Old Norse, Medieval Welsh and Germanic philology, as well as early English literature. His professional career and personal interests now ran side by side. His study of the languages of north-western Europe honed his own skills in language creation, whilst his exploration of the northern and Germanic myths and legends contained in the early literature mirrored his own forays into world-building and his invention of a new mythology.

Clearly some of the texts he studied in his professional life directly influenced his own literary work, such as the hobbit's theft of a cup from Smaug's hoard, which rouses the dragon's fury – a clear echo of the theft of a jewelled goblet from the dragon's hoard in the Old English epic poem *Beowulf* which similarly enraged its guardian, leading ultimately to Beowulf's death. Although fascinating and sometimes

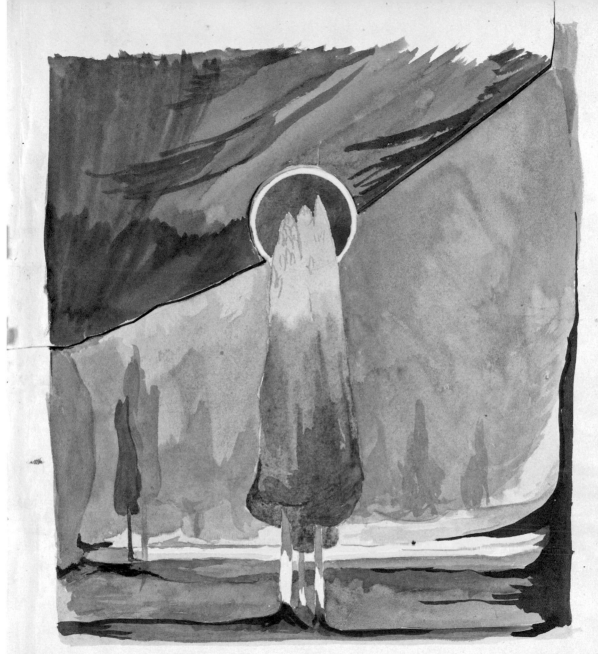

The Land of Pohja.

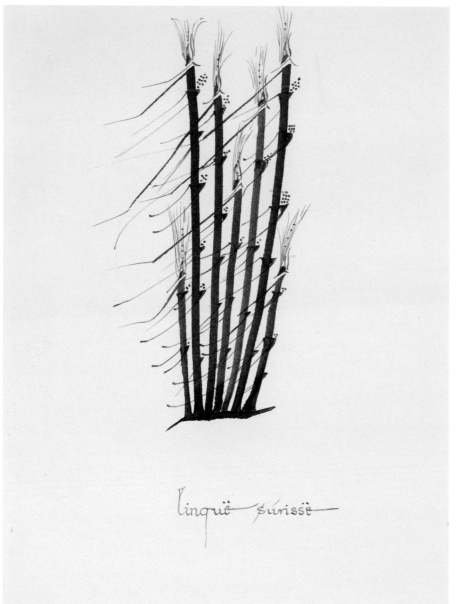

linquë súrissë

'linquë súrissë'
The title is Quenya for 'grass in the wind', [1960s]
Quenya was one of the Elvish languages invented by Tolkien.
Black ink
MS. Tolkien Drawings 91, fol. 65

'Wudu wyrtum faest'
Grendel's mere from the Old
English epic poem *Beowulf* (line
1,364), 'tree held fast by its roots',
July 1928
Black ink, pencil
MS. Tolkien Drawings 88, fol. 17

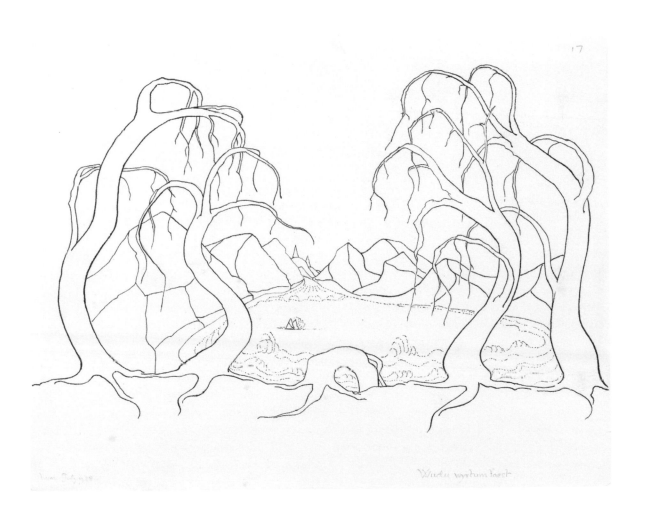

Wudu wyrtum faest

'High Life at Gipsy Green'
Sketches of early married life,
showing Tolkien, Edith and baby
John, [1918]
Pencil, coloured pencil
MS. Tolkien Drawings 86, fol. 25v

enlightening, the search for sources in Tolkien's fiction can only lead so far, whilst the actual moment of creation remains elusive. When asked about sources for *The Lord of the Rings*, Tolkien alluded to the mystery of creation whilst also acknowledging the possible influence of everything that he had ever read, heard or experienced: 'sheer invention so far as one can "invent" anything, more than new patterns of old colours'.[3] The languages and legends of Middle-earth, which he began creating perhaps as early as 1910 whilst still at school, were ultimately his own unique invention. Many of the tales in *The Silmarillion*, published after his death in 1977, are recognizable from the earliest versions which he wrote in the period 1916–20. Although he worked on them throughout his adult life, his remarkable vision for the legendarium was so strong that it was mostly untouched by external influences over a period of almost sixty years.

C.S. Lewis declared, 'No one ever influenced Tolkien – you might as well try to influence a bandersnatch' (referring to the ferocious fictional creature created by Lewis Carroll).[4] Yet it was to Lewis's encouragement that Tolkien attributed the completion of *The Lord of the Rings*, when he wrote, 'only by his support and friendship did I ever struggle to the end of the labour'.[5] The two men had met as young academics at Oxford in 1926 and soon discovered that they shared a love of myths and legends, particularly those of northern Europe. They read their own works aloud to each other and their friendship grew to encompass a group of like-minded men, who called themselves the Inklings. This group, really an informal band of friends, lacked the accoutrements of a typical university club, such as rules, registers of members and minute books. It was ostensibly a literary group whose 'members' read aloud their works in progress but in these boisterous meetings of minds, all learned and Christian, Tolkien enjoyed a male camaraderie which provided a welcome release from the pressures of academic life and the responsibilities of home and family. They met regularly to drink, debate, discuss and most of all to entertain one another. Tolkien read the whole of *The Lord of the Rings* to the Inklings in chapters as it was written but Lewis recalled, 'We listened to his work, but could affect it only by encouragement. He has only two reactions to criticism: either he begins the whole work over again from the beginning or else takes no notice at all.'[6]

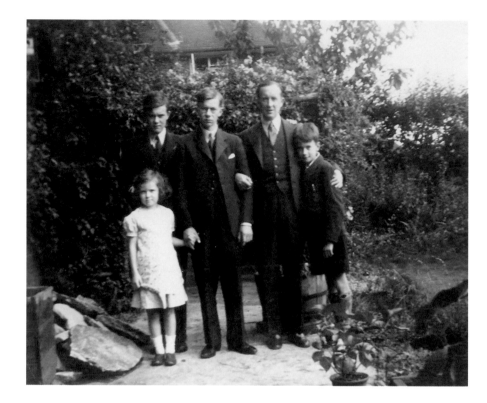

Perhaps Tolkien *was* immune to the criticisms of his friends and fellow Inklings, but it is not true to say that no one ever influenced him. The clearest evidence comes from looking closer to home, and to those who were closest to his heart. His wife, Edith, was the first person to read the tales that would become *The Silmarillion*. Whilst on sick leave from the Army in 1916, Tolkien began to write down the tales of the Elves in a series of small exercise books. It was December and he had been discharged from the military hospital in Birmingham which enabled him to spend Christmas with his wife in Great Haywood: their first Christmas together as a married couple. It was here that he

began to write *The Book of Lost Tales*. He was still weak and recovering from trench fever, a debilitating illness spread by lice in the fetid conditions of the trenches. Edith gave help and encouragement by copying out the first stories he wrote in her neat cursive hand. In fact she not only read the stories and helped him to write them out: she was also a source of inspiration for them. When he was assigned to a defensive regiment on the east coast of Yorkshire the following year, Edith accompanied him, living nearby. His ill health had provided a temporary reprieve from the trenches and the young couple must have rejoiced in their time together. During a woodland walk, Edith sang and danced for him in

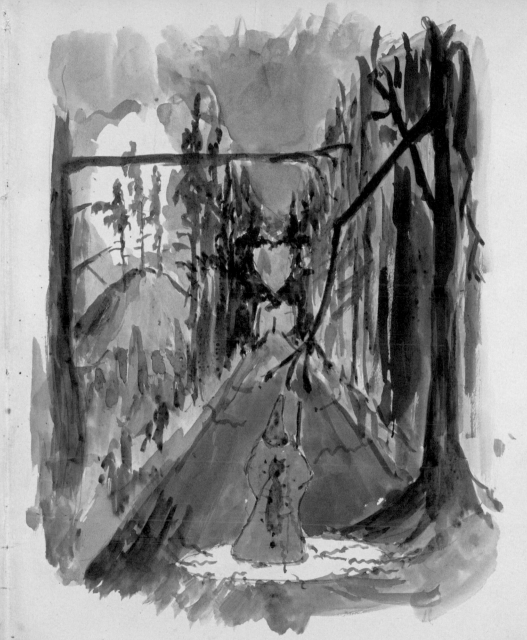

EERINESS

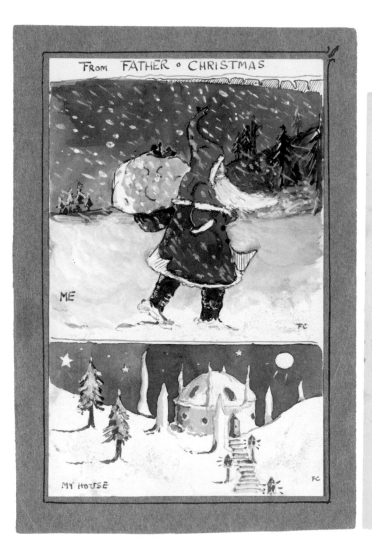

The first letter from Father Christmas
22 December 1920
Letter – red and black ink, silver powder; drawing – watercolour, white bodycolour, silver powder, black ink
MSS. Tolkien Drawings 37–8

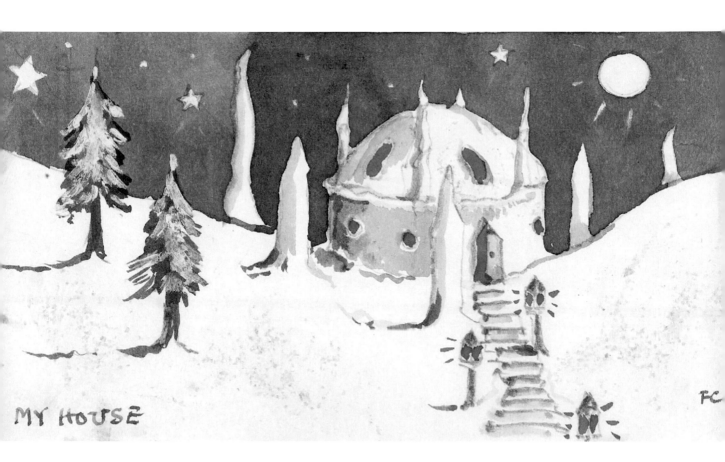

MY HOUSE

FC

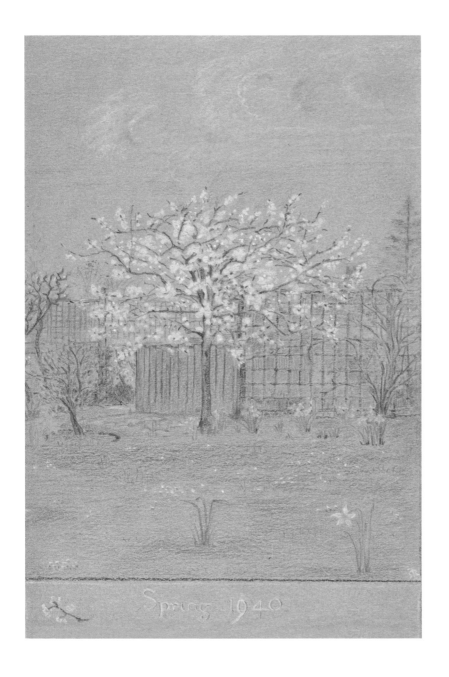

'Spring 1940'
Flowering tree in Tolkien's garden, 20 Northmoor Road, Oxford
Coloured pencil, pencil on blue-grey paper
MS. Tolkien Drawings 89, fol. 5

'Num[enórean] Ceramic Grass patterns'
February 1960
Coloured ballpoint on newspaper
MS. Tolkien Drawings 94, fol. 11

a dappled glade. 'With her long dark hair, fair face and starry eyes', she became the inspiration for the Elven princess, Lúthien Tinúviel, whose song captivated the wandering Beren in the woods of Doriath.[7] The love story of Beren and Lúthien, the first between mortal Man and immortal Elf, lies at the heart of *The Silmarillion*, and is an echo of Tolkien's love for Edith. When she died he had the name of the Elven princess inscribed on her gravestone. By way of explanation, he told his son Christopher, 'she was (and knew she was) my Lúthien'.[8]

His marriage to Edith lasted for fifty-five years, until her death in 1971. Their lives were bound initially by their youthful love and then by their marriage and the happy arrival of four children. Tolkien's family life provided him with the stable, loving environment that he had lost during his own childhood when he was orphaned aged twelve. His children were a source of great joy to him and he was fortunate in having a job that enabled him to spend so much time at home with them. When his children were young, during the twenty-year period when he was the Rawlinson and Bosworth Professor of Anglo-Saxon at Oxford (1925–45), he did not have rooms in college but used his study at home to teach graduate students, prepare lectures and mark examination papers. He was a constant presence in his children's lives, and his study, rather than being out of bounds, was the place where they would gather in the

'Numenorean Ceramic Patterns'
March 1960
Black ink, coloured ballpoint on newspaper
MS. Tolkien Drawings 94, fol. 12

evenings to listen to stories written specially for them. One of these stories was *The Hobbit*, which became the first published tale of Middle-earth. This tale brought elements from northern legends and sagas into the margins of his own legendarium set in a remote Elvish past and it entwined them with his own creation, the parochial and comical hobbits. By writing to entertain his children, he had found a new authorial voice; one that was more accessible and appealing than the high epic style he employed in his unpublished 'Silmarillion' writings, and one which would bring his Elvish mythology to a much wider audience. *The Lord of the Rings*, written as a sequel to *The Hobbit*, was dedicated to his children, who read it avidly as it was written and encouraged him, over many years, to complete it.

Much of Tolkien's literary work, whether for children or adults, was illustrated by him. These illustrations range from rough pencil sketches of the topography of an imagined place to finished watercolour landscapes, and from pen-and-ink drawings of ancient artefacts to detailed dust jacket designs. Art and literature were closely connected for him. He was initially taught to draw by his mother and later received lessons in drawing at school. However, it was only when he left behind his formal art education that he embarked on a period of discovery and began to try his hand at different styles. His undergraduate years at Oxford were marked by

a period of experimentation, as he eschewed painting and drawing from real-life in favour of abstract expressionism with a series of paintings and drawings that he called 'Ishnesses': an attempt to express feelings or abstract ideas visually. Later, when he became a father, he created many wonderful illustrations to accompany the stories he wrote for his children. The letters from Father Christmas which the Tolkien children received every year, depicting the accidents and escapades that had imperilled Christmas, show Tolkien's talents as an author and illustrator. Even the 'grim and tragic' tales from his Elven mythology, written purely for an adult audience, were illustrated with watercolour paintings and drawings, so that visual depictions gradually emerged of the secondary world that he was creating – the world that would become Middle-earth.[9] Later in life his work on 'The Silmarillion' became all-encompassing, and previously unconnected tales, poems and designs were drawn into its orbit, such as the abstract designs on newspaper which became pottery designs associated with the Númenórean civilization of the Second Age of Middle-earth.

Towards the end of his life, Tolkien was asked by an interviewer how he thought he would be remembered. Comparing himself to the poet Longfellow, who is more likely to be known as the author of the 'Song of Hiawatha' than as a professor of modern languages, he predicted that his academic work would one day be overshadowed by his literary work: that he would in fact be remembered as the author of *The Lord of the Rings*.[10] This book celebrates Tolkien as an outstanding, perhaps the pre-eminent, fantasy author of modern times but also affirms the importance of the many different aspects of his life – philologist, inventor of languages, artist, designer, academic, teacher, husband and father – roles which combined to produce a unique set of talents and which set his extraordinary imagination on the path to the creation of Middle-earth.

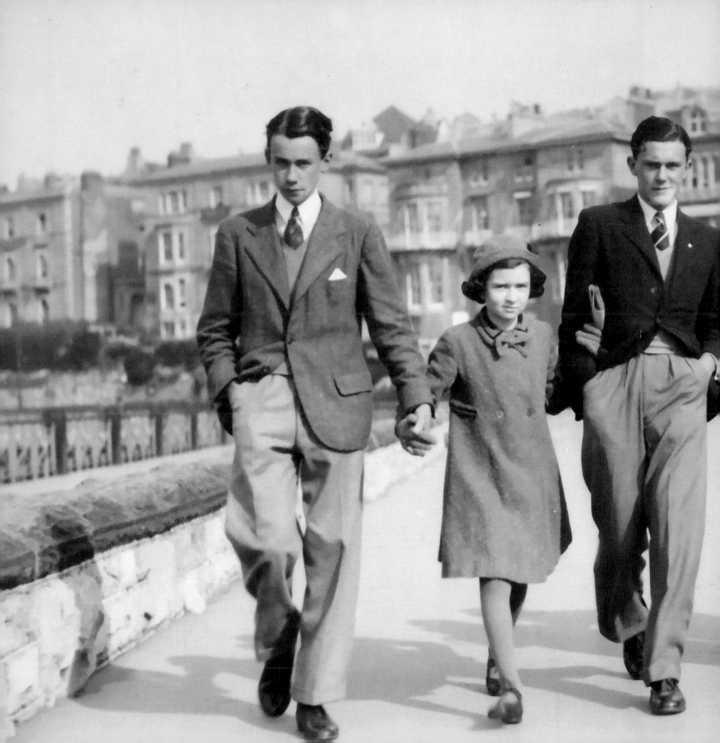

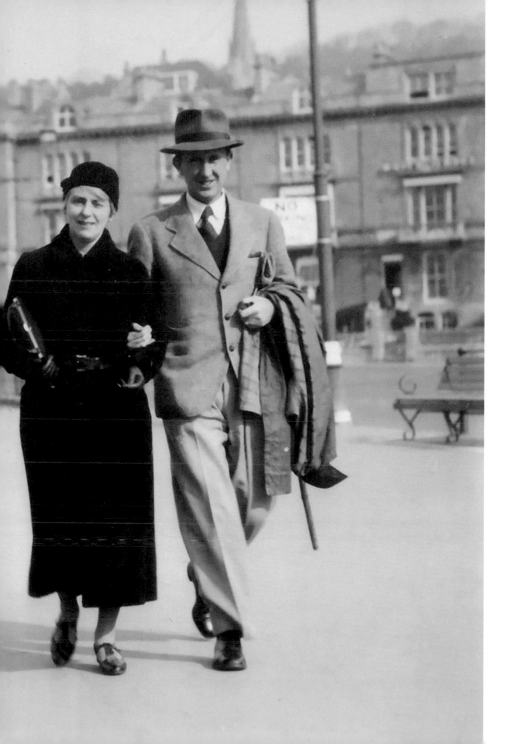

Family at Weston-super-Mare
Christopher, Priscilla, Michael,
Edith and Tolkien, 11 April 1940
MS. Tolkien photogr. 6, fol. 1

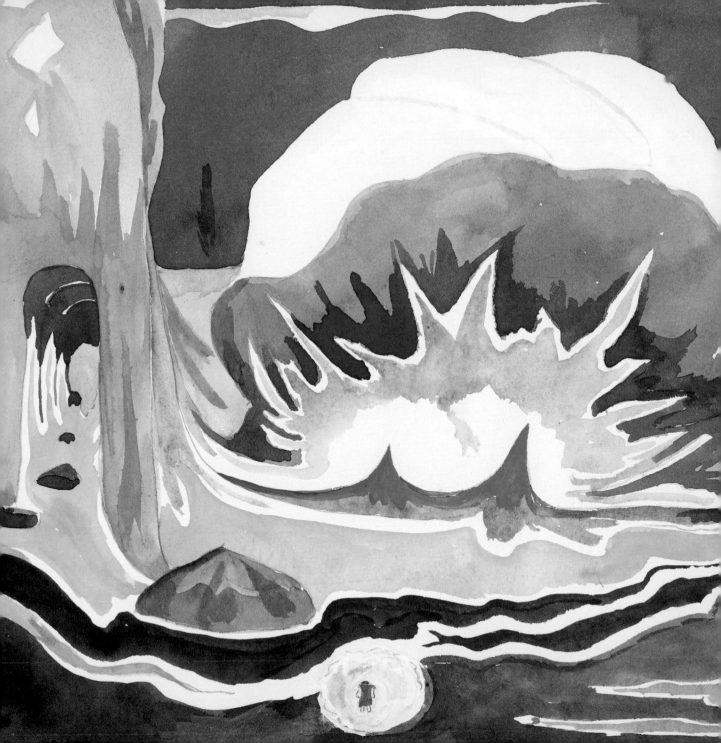

Early Years and War

John Ronald Reuel Tolkien was born in 1892 in Bloemfontein, in the Orange Free State, to English parents, Arthur and Mabel. His father was a bank manager and his early years were spent in relative comfort in the small town on the high African veldt. When he was aged three, his mother took him and his younger brother, Hilary, to England for an extended stay with their family in Birmingham. During this visit his father died suddenly in Africa from complications arising from rheumatic fever. The family did not return to Bloemfontein but embarked on a new life in Sarehole, a village just outside Birmingham. Despite living in reduced circumstances, this was an idyllic period in his childhood and later inspired the fictional rural backwater of the Shire.

He was tutored by his mother, winning a scholarship to King Edward VI School in Birmingham, where he excelled in languages and debates. In 1904 his mother died from diabetes, then an untreatable condition. The two young brothers were left in the care of a Roman Catholic priest, Father Francis Morgan, who supported them emotionally and financially. A romance with a fellow orphan, Edith Bratt, who lived in the same lodging house, was cut short by his guardian, who insisted that Tolkien concentrate on his studies. He won a scholarship to study Classics at Exeter College, Oxford, in 1911, and being both studious and gregarious he greatly enjoyed his four years at university. During this period four important events occurred: he switched from Classics to English so that he could develop his interest in Germanic languages; he was reunited with his childhood sweetheart, Edith; he began to develop the languages and mythology of the Elves and the First World War began.

The rush by undergraduates to enlist decimated the population of the university, but Tolkien completed his studies, throwing his energy into his final exams, feverishly working on his burgeoning mythology, as well as marching and drilling with the other cadets as part of his officer training. He graduated with a First Class degree in 1915 and joined the Army proper. Within a year he and Edith had married, and he was in France awaiting the start of the Somme offensive in July 1916. Many of his friends did not survive the war and the experience acted as a catalyst on Tolkien. By the end of 1916 he had been invalided home and began writing his Elvish mythology in earnest.

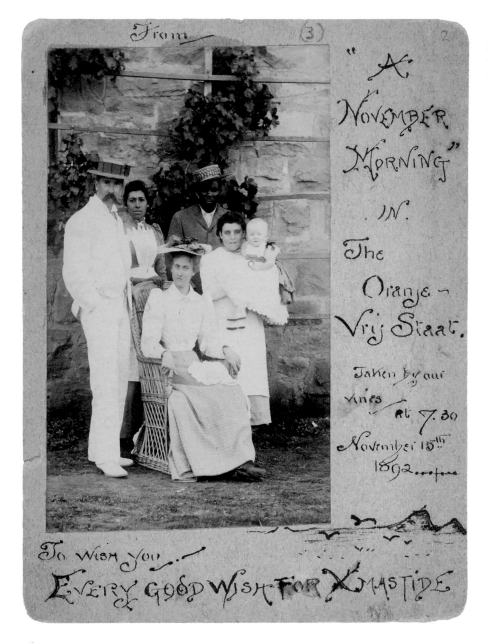

Family photograph with household servants
with annotations by Mabel Tolkien. Bloemfontein, 15 November 1892
MS. Tolkien photogr. 4, fols. 2–3

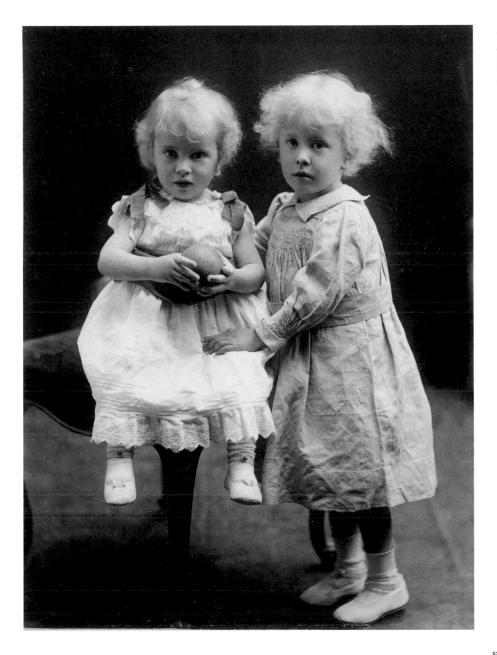

Tolkien (standing) **and his younger brother, Hilary**
Birmingham, September 1895
MS. Tolkien photogr. 4, fol. 6

Tolkien's first letter, dictated to his nurse
Birmingham, 14 February 1896
Tolkien family papers

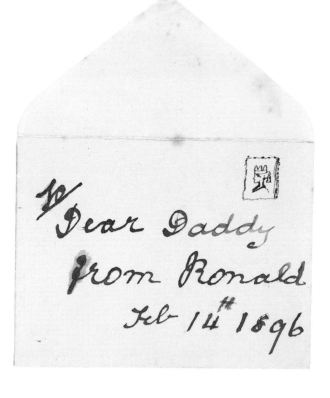

✝✝ ✝ ✝ X
✝ X ✝ X
✝ ✝ X

9 Ashfield Rd
Kings Heath
Feb 14th 1896

My Dear Daddy
I am so glad
I am coming back
to see you it is
such a long time
since we came
away from you
I hope the Ship

½
Dear Daddy
from Ronald
Feb 14th 1896

Landscape from an early sketchbook
[*c.*1906]
Watercolour
MS. Tolkien Drawings 84, fol. 28r

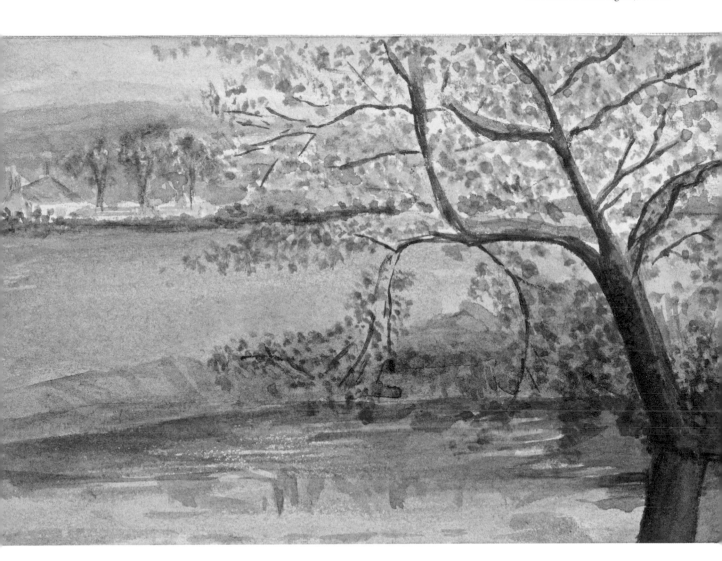

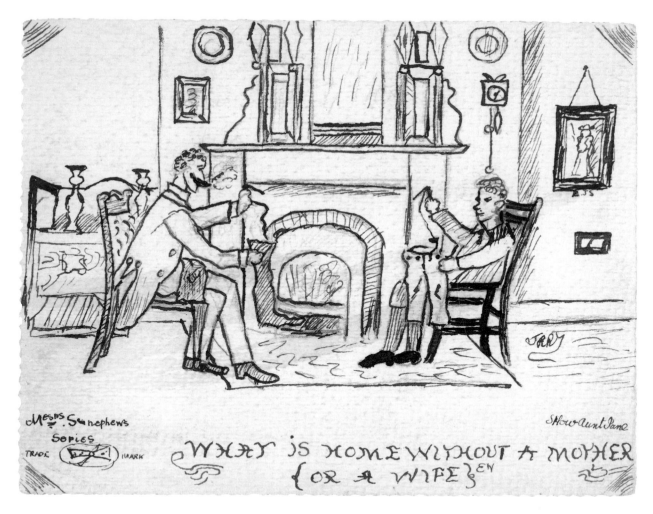

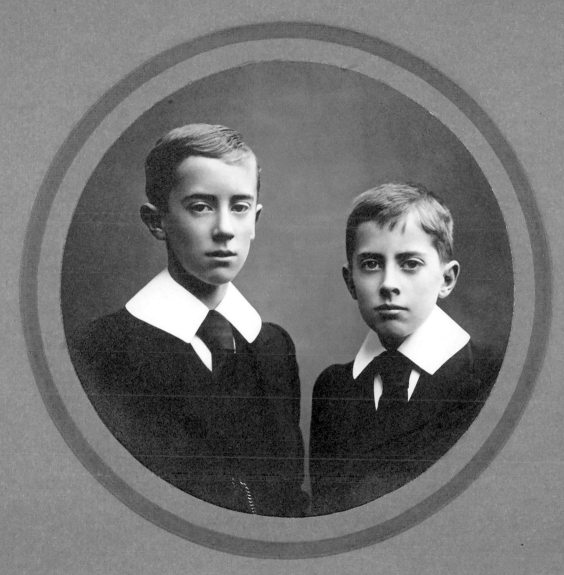

HAROLD BAKER
17 CANNON STREET
BIRMINGHAM

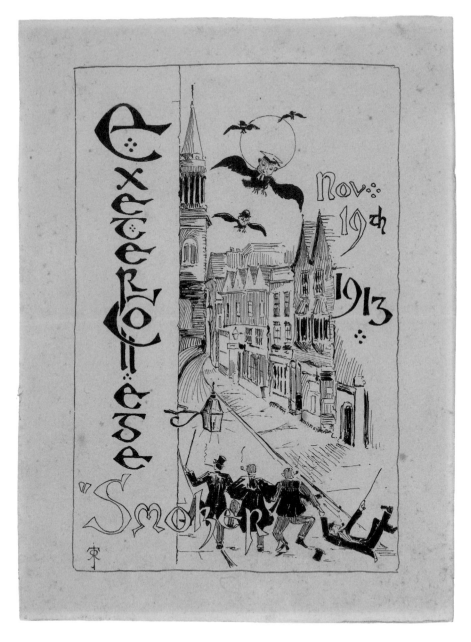

'Exeter College Smoker'
Programme design for a college
concert, 19 November 1913
Black ink
Tolkien family papers

'Undertenishness'
A painting from 'The Book of
Ishness', [1912]
Watercolour, black ink, coloured
pencil, pencil
MS. Tolkien Drawings 88, fol. 13r

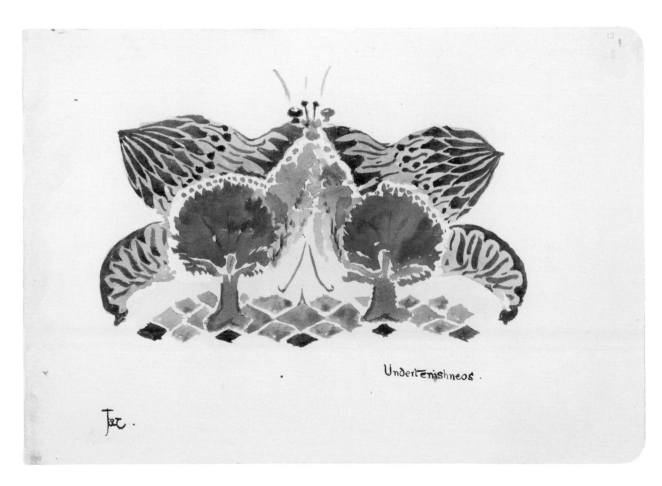

Undertenishness .

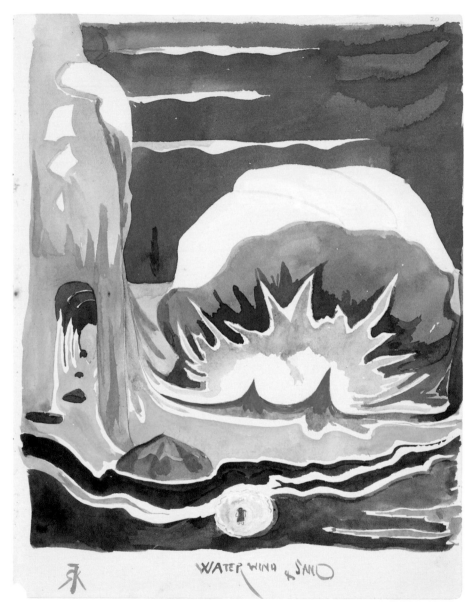

'Water Wind & Sand'
An illustration for his poem,
'Sea-Song of an Elder Day', [1915]
Watercolour, white bodycolour,
pencil
MS. Tolkien Drawings 87, fol. 20

Tolkien in his final year at King Edward VI School
Birmingham, January 1911
MS. Tolkien photogr. 4, fol. 16

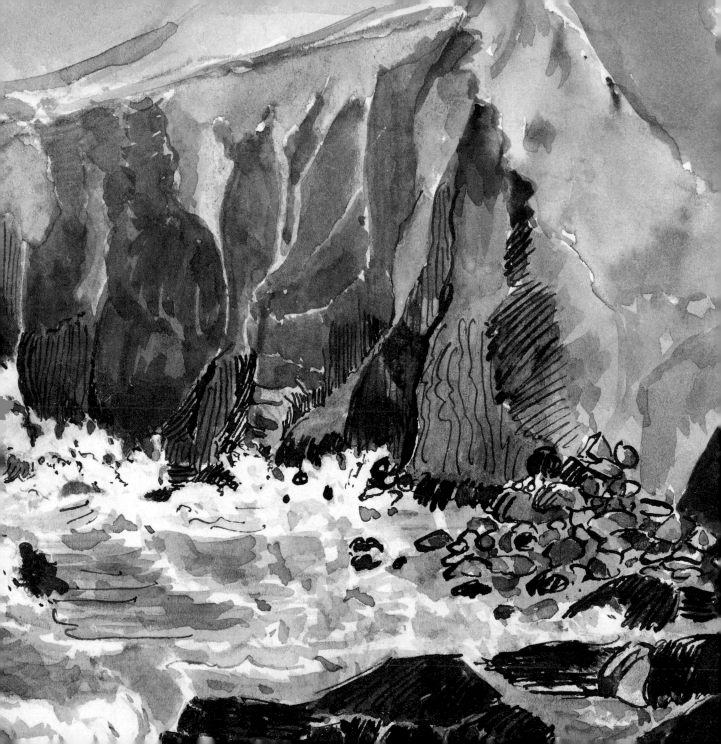

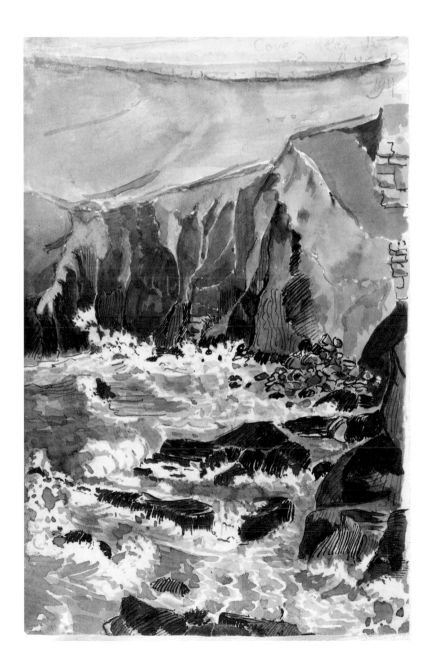

'Cove near The Lizard'
A watercolour painted on
holiday in Cornwall at the
outbreak of the First World War,
12 August 1914
Black ink, watercolour
MS. Tolkien Drawings 85, fol. 13r

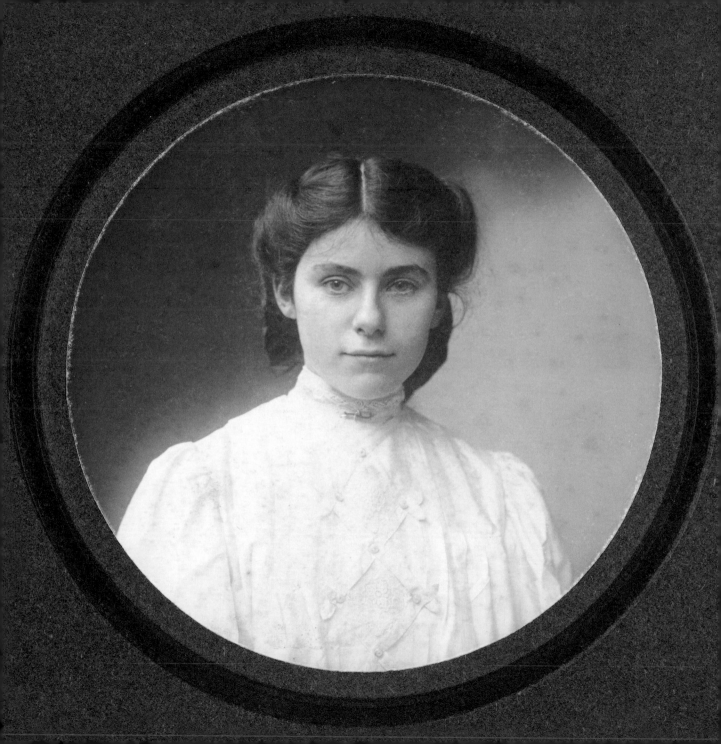

opposite **Edith Bratt, aged seventeen**
Birmingham, 1906, given to Tolkien
as a keepsake in 1909
MS. Tolkien photogr. 16, fol. 1

Account book
Recording number of hours spent in
study and number of corresponding
kisses owed by Edith, 1913
Tolkien family papers

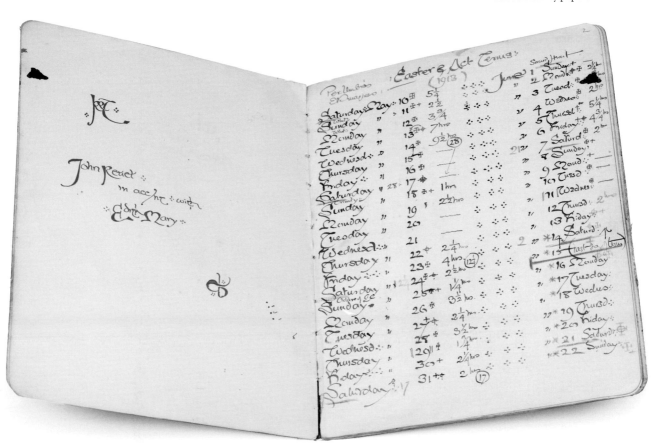

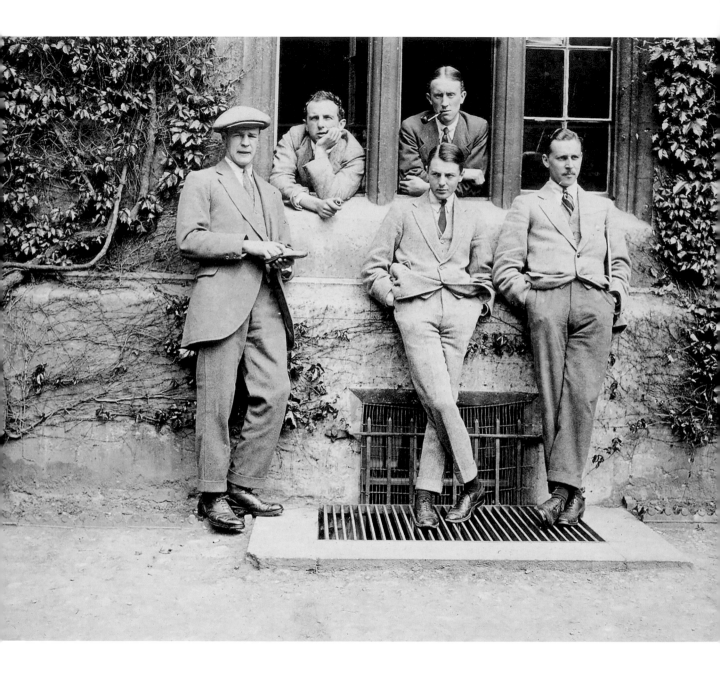

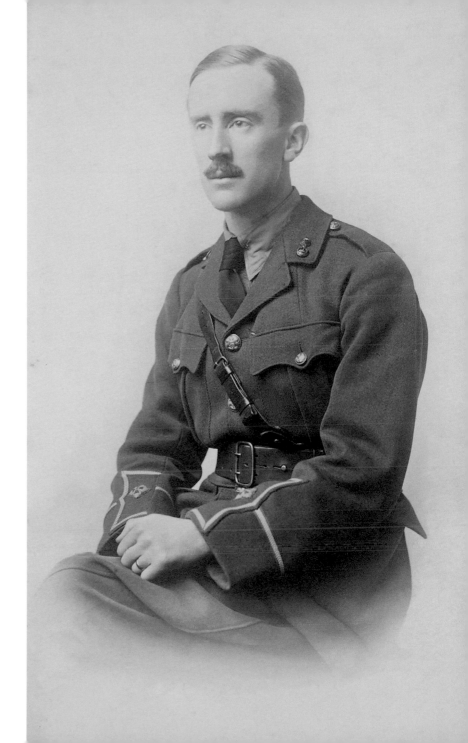

opposite **Tolkien** (smoking pipe at window) **with friends**
Exeter College, Oxford, May 1914
From left to right:
G.C.N. Mackarness, Charles Cartwright,
J.R.R. Tolkien, Anthony Shakespeare and
B.J. Tolhurst
MS. Tolkien photogr. 4, fol. 32

right **Tolkien, Second Lieutenant,
13th Lancashire Fusiliers**
Birmingham, 1916
MS. Tolkien photogr. 4, fol. 33

Scholar and Author

'He was the sort of painter who can paint leaves better than trees. He used to spend a long time on a single leaf, trying to catch its shape, and its sheen, and the glistening of dewdrops on its edges. Yet he wanted to paint a whole tree, with all of its leaves in the same style, and all of them different.'[1] This extract from Tolkien's allegorical short story, 'Leaf by Niggle', is a poignant expression of his own creative struggles as he sought to bring his works, both literary and academic, to completion. The story was written in the early 1940s as he worked fitfully on *The Lord of the Rings*, his Elvish languages and his wider legendarium, all of which seemed very far from completion. Similarly, much of his academic work remained unpublished and the only beneficiaries of his detailed commentaries and illuminating thoughts on Old and Middle English texts were the students he taught and supervised.

There were many reasons for the large number of unfinished and unpublished works amongst his papers. Firstly, he was a perfectionist and the very thought of publication led him, not only to revise, but to rewrite a work from the beginning. Secondly, he was extremely conscientious in his many different roles, whether it was giving far more lectures than necessary or tending to his garden with meticulous care or writing detailed letters from Father Christmas for his children, complete with hand-made postage stamps and watercolour illustrations. He was incapable of tackling any task half-heartedly. Thirdly, he was a man of many talents. With unlimited time, such as he gave to his immortal Elves, he might have been able to bring all his translations, editions, stories and languages to fruition, but his own time was not unlimited and with so many different demands and interruptions he found it impossible to concentrate on one task for long enough to complete it to his satisfaction. In the final analysis he may have been unable to take the final steps that would set his works definitively in print, because in a sense this would bring his relationship with them to an end. His many unfinished works, including 'The Silmarillion' and his invented languages, were unfinished because he did not want them to be – because he did not want his work on them to end.

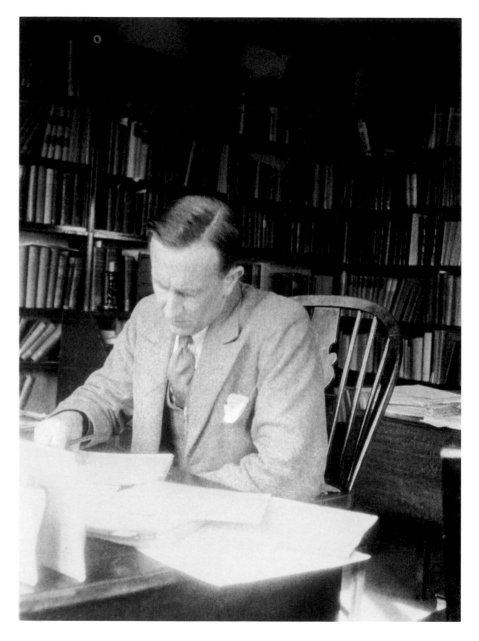

Scholar and author
Tolkien at work in his study,
20 Northmoor Rd, Oxford, [*c*.1937]
MS. Tolkien photogr. 5, fol. 94

Family holiday in Filey
Tolkien with his sons, Michael
and John, September 1925
MS. Tolkien photogr. 5, fol. 11

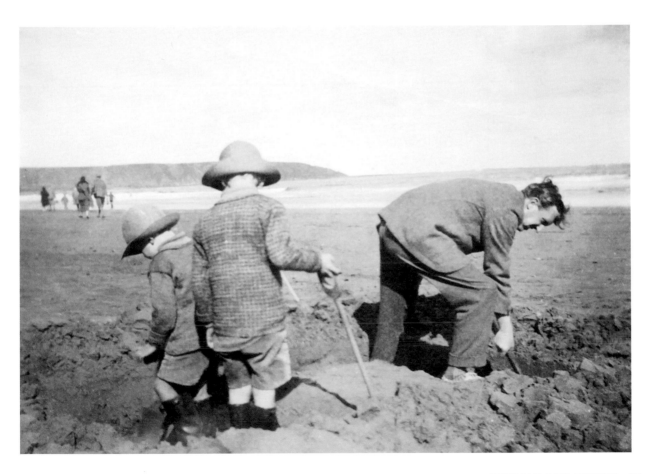

'House where *Rover* began his adventures as a *toy*'
Illustration for *Roverandom*, a story created by Tolkien for his children while on holiday in Filey, September 1927
Watercolour, black ink
MS. Tolkien Drawings 89, fol. 2

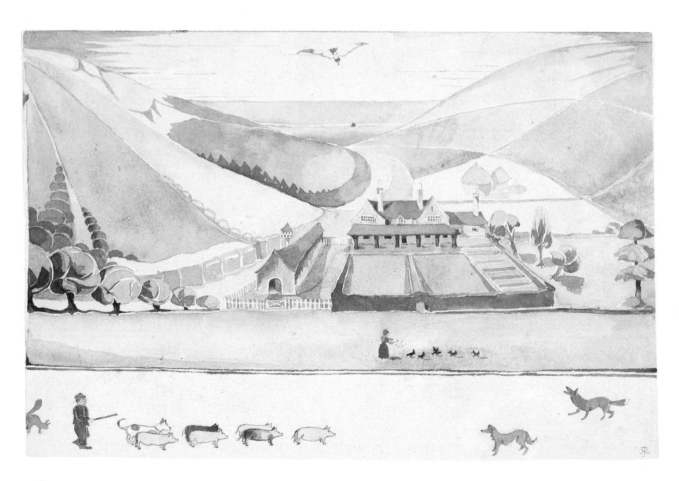

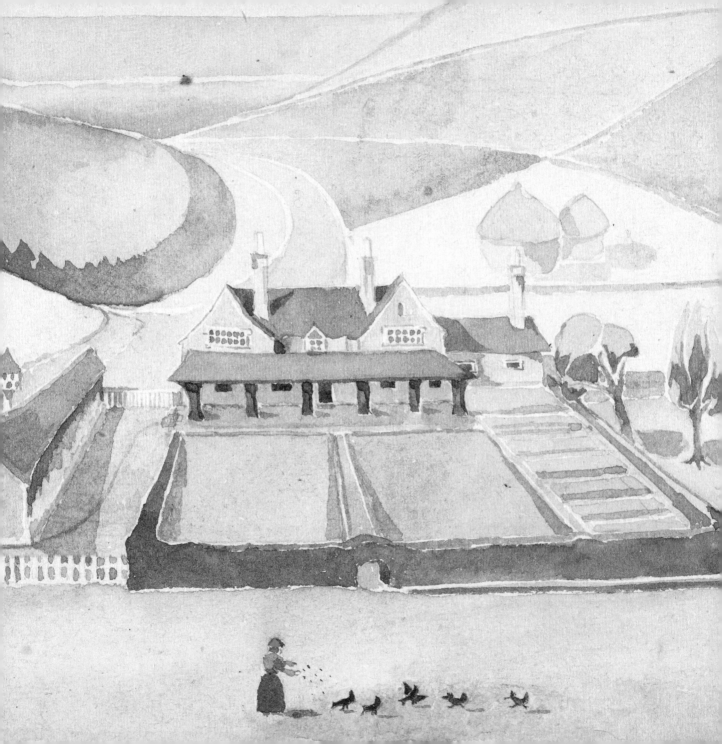

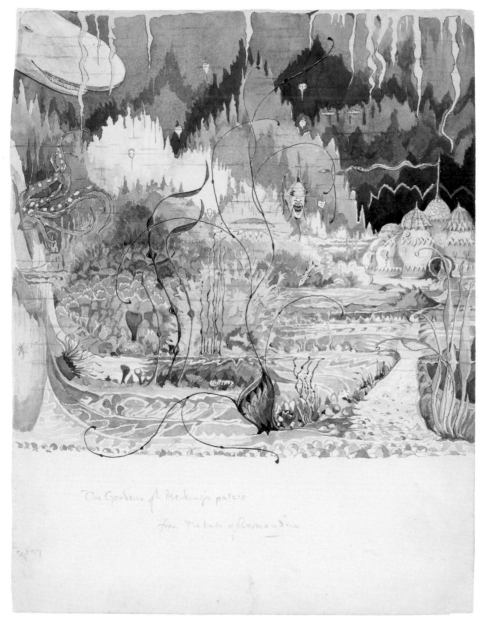

'The Gardens of Merkings palace

from The tale of Roverandom'

'The Gardens of the Merking's palace'
Illustration for *Roverandom*,
September 1927
Detail shows, on the right, the Merking's palace where the mer-folk sang and danced in the great ballroom.
Watercolour, black ink, pencil
MS. Tolkien Drawings 89, fol. 4

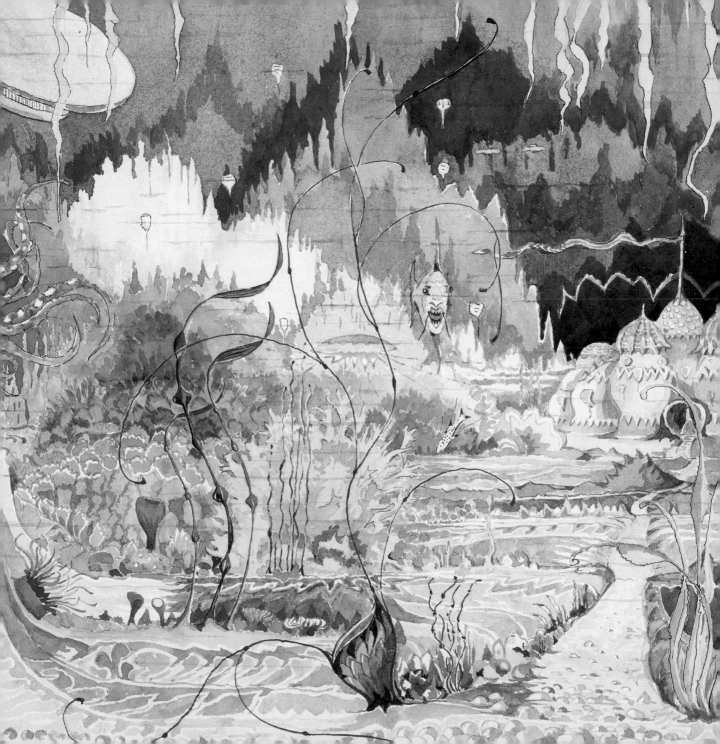

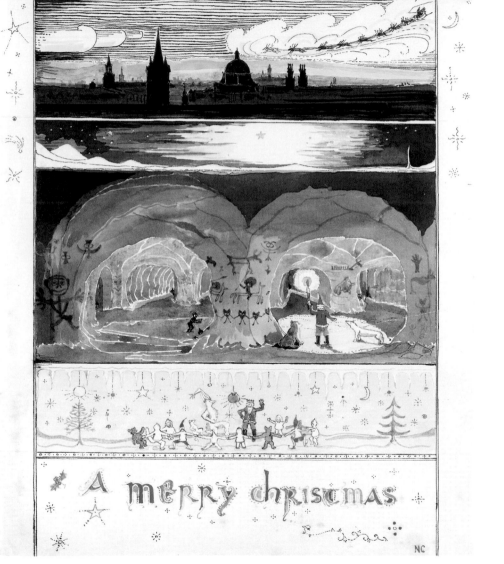

'A Merry Christmas'
1932
Detail shows the Oxford skyline,
with three vertical lines on the
right indicating the location of the
Tolkien family home.
Watercolour, black and coloured ink
MS. Tolkien Drawings 57

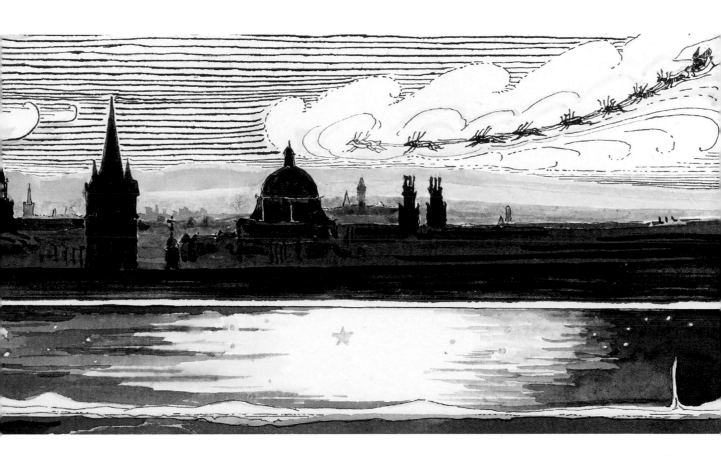

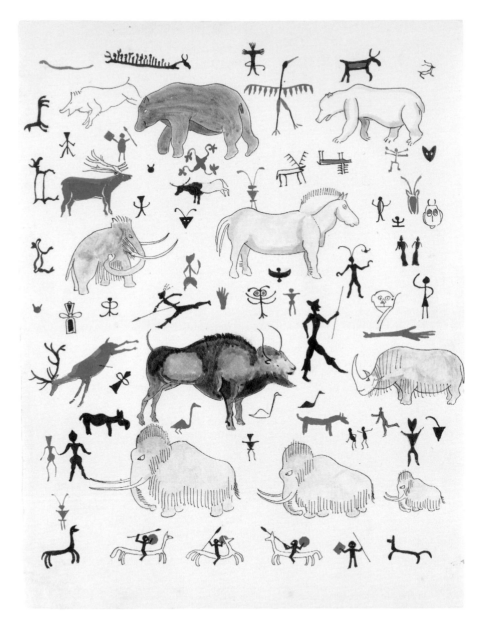

Cave drawings
'Copied' by Father Christmas and
enclosed in his letter, 1932
Black and red ink, watercolour
MS. Tolkien Drawings 58

left

Prose translation of *Beowulf*

1926

Typescript, with manuscript
annotations in black ink and pencil
MS. Tolkien A 29/1, fol. 66

opposite

'hringboga heorte gefysed'

September 1927

This translates as 'now was the
heart of the coiling beast stirred',
Beowulf, line 2,561.

Watercolour, black ink
MS. Tolkien Drawings 87, fol. 37

hringboga heorte gefysed

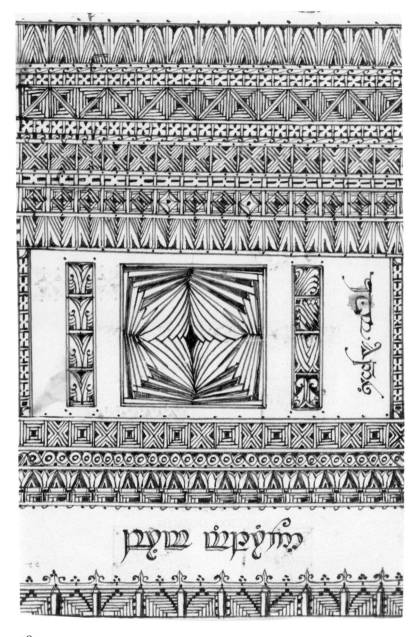

'parma mittarion'
Quenya for 'book of enterings',
perhaps intended as a cover
design for a book that was never
completed, [?1957]
Black ink
MS. Tolkien Drawings 91, fol. 22r

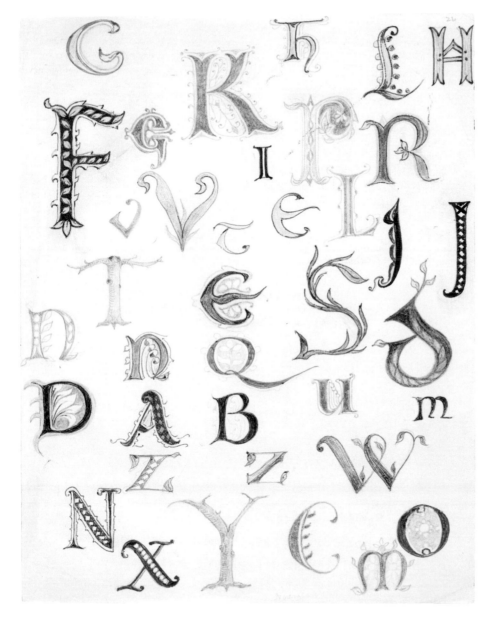

Decorative alphabet
Many of the decorations are
botanical in nature,
November 1960
Coloured pencil, coloured
ballpoint, black ink, pencil
MS. Tolkien Drawings 91,
fol. 24

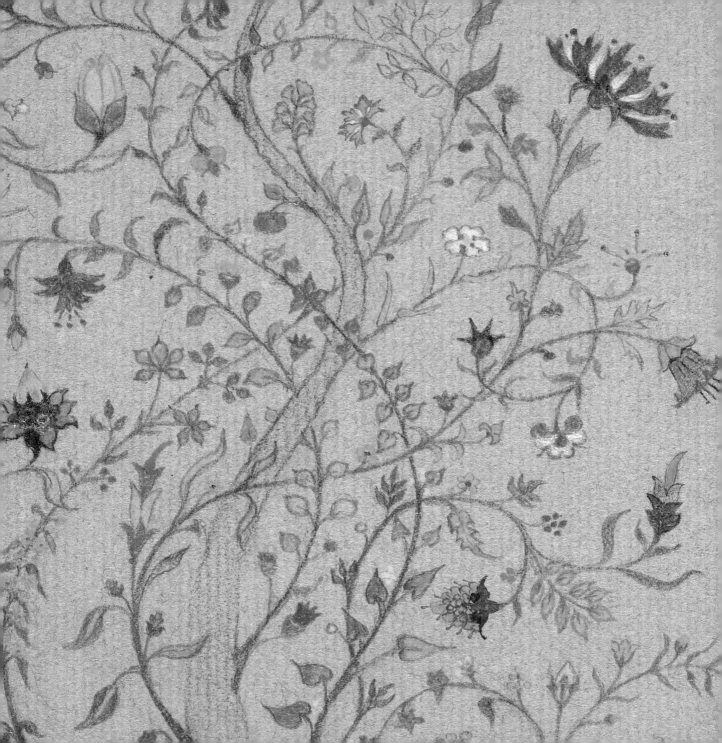

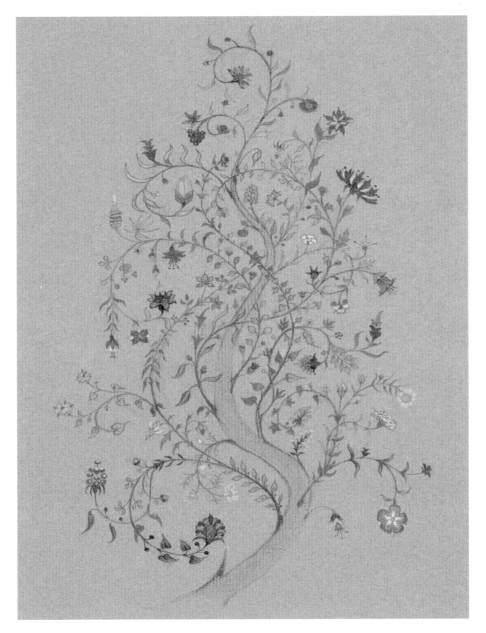

The Tree of Amalion
A tree bearing many different leaves and flowers was a recurring motif in Tolkien's art, [?1940s]
Coloured pencil, watercolour, silver paint, black ink on grey paper
MS. Tolkien Drawings 88, fol. 1

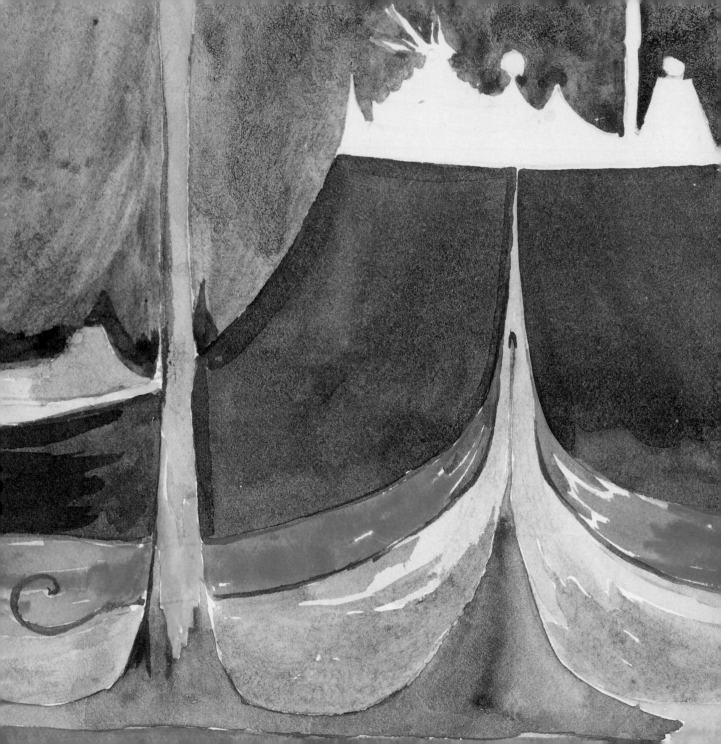

The Silmarillion

The Silmarillion is the history of the Elves, told from the creation of the world to the end of the First Age: a period known as the Elder Days. It tells of the awakening of the Elves in Middle-earth; their journey to, and blissful sojourn in, Valinor, the Land of the Gods; their creation of the Silmarils, the three great jewels which contained the unsullied light of the Two Trees; the theft of these jewels by the evil god, Morgoth, and the long quest of the Elves to reclaim them from his stronghold in the north-west of Middle-earth. In the course of this history they rebel against the Gods, spill the blood of fellow Elves and form and break alliances with Men and with each other. It is a bitter history of vengeance, treachery and death, interspersed with tales of heroism, sacrifice and love.

The history of the Elder Days covered a period of several thousand years. Filling this time-span with a chronological history, vivid tales and evolving languages was a huge undertaking and one which occupied Tolkien throughout his life. Poems and drawings such as 'Tanaqui' and 'Shores of Faery' show that he was working on the legends when he was an undergraduate at Oxford, and he later claimed, 'I do not remember a time when I was not building it.'[1] Since childhood he had created his own languages and alphabets and by 1915 he was at work on the first of his Elvish languages, Qenya (later Quenya). The languages led to the invention of the mythology. 'Anyone who invents a language finds that it requires a suitable habitation and a history in which it can develop' he later explained, and so it was that 'The "stories" were made rather to provide a world for the languages than the reverse.'[2]

For more than fifty years Tolkien wrote, revised and reworked the tales of Elves and Men, in prose and in verse, illustrating them with vivid paintings, watercolour landscapes, heraldic devices, decorative patterns and detailed maps. *The Silmarillion* was not published in his lifetime, but its underlying history, geography and languages gave a sense of great depth and historicity to the published works of Middle-earth: *The Hobbit* and *The Lord of the Rings*.

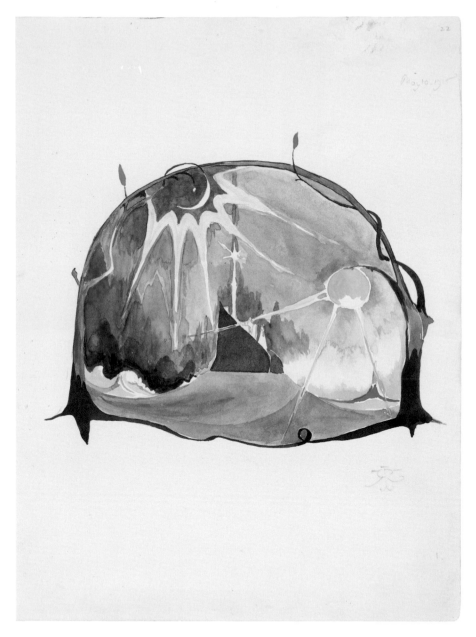

The Shores of Faery
Illustration showing the Two
Trees of the Sun and Moon in
Valinor, 10 May 1915
Watercolour, black ink, pencil
MS. Tolkien Drawings 87,
fol. 22r

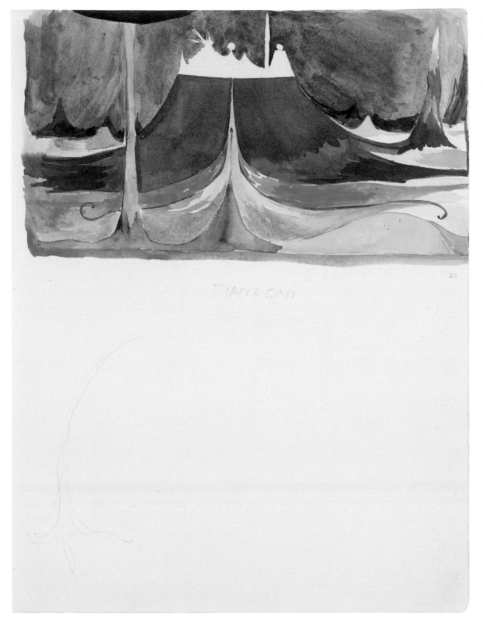

'Tanaqui'
The city of the Elves in Valinor,
[1915]
Watercolour, pencil
MS. Tolkien Drawings 87, fol. 21r

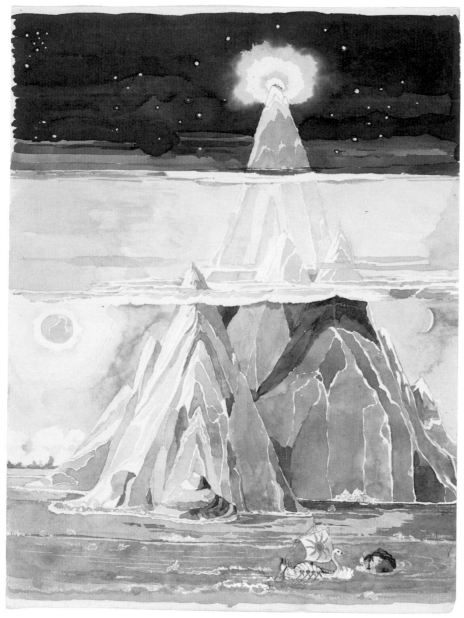

'Halls of Manwe on the Mountains of the World above Faerie'
July 1928
Detail shows the swan boat and the Elven city of Alqualondë (Swanhaven) beyond.
Watercolour, white bodycolour, black ink
MS. Tolkien Drawings 89, fol. 13

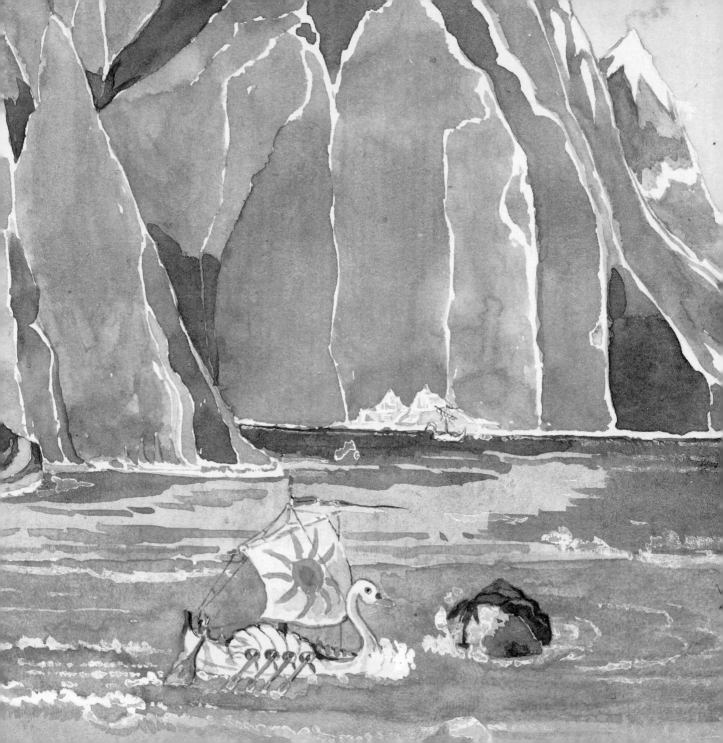

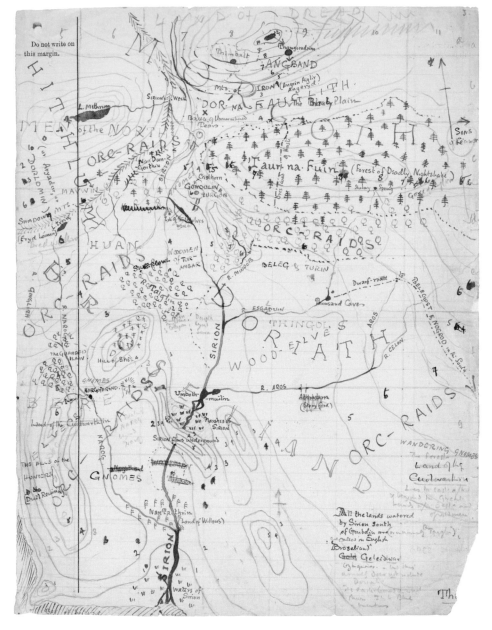

The first Silmarillion map,
[1920s]
Detail shows the northern
part of the map, dominated by
Morgoth and the deadly forest
of Taur-na-Fuin.
Pencil, black, red and green ink
on lined paper
MS. Tolkien S 2/X, fol. 3r

L. Mithrim

MTS

SIRION'S WELL

Thimbalt

Thangorodrim

125
18
9
8

ANGBAND

Mts. of IRON (Angrin Aiglir)
Angeryd

DOR · NA · FAUGLITH

The Barely Plain

X Battle of Unnumbered Tears

EN of the NORTH

ORC- RAIDS

SIRION

Nan Dun-Gorthin

GNOMES

Cristhorn

GONDOLIN
TURGON

Taur · na · Fuin (Forest of

Orcs Road of Haste

Shadowy Spr

MAVWIN

(or Aryador, or
DORLOMIN)

MTS.

Down
d Lomin]
red well

L. Evrin

HUAN

Isle of the Wolves
Were-

WOODMEN of TUR-
AMBAR

ORC - RAIDS

BELEG & TURIN

Dwarf-road

R.

SILVER BOWL

R. Taiglin

R. MINDEB

R. ESGADUIN

R.
NAROG

THE GUARDED
PLAIN

Doriath
Lying's

Hill of Spies

SIRION

Thousand Caves

THINGOLS
WOOD-ELVE

DORIATH

AROS

GNOMES

NARGOTHROND.

Umboth-
-muilin

R. AROS

Aillwasirn

6

'Mithrim'
The area around Lake Mithrim in
the land of Hithlum, 1927
Watercolour, black ink, pencil
MS. Tolkien Drawings 87, fol. 33

'Beleg finds Flinding in Taur-na-Fúin'
Illustration later entitled, 'Fangorn Forest',
July 1928
Watercolour, black and coloured ink
MS. Tolkien Drawings 89, fol. 14

Detail shows the Elven huntsman, Beleg, approaching the exhausted figure of Flinding, an Elf of Nargothrond who had escaped from the mines of Morgoth.

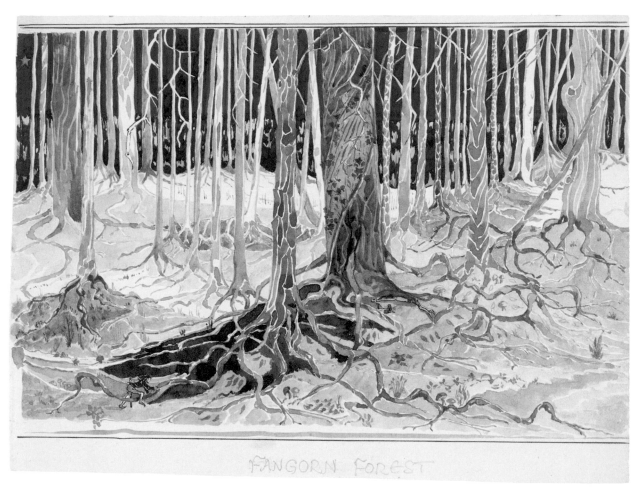

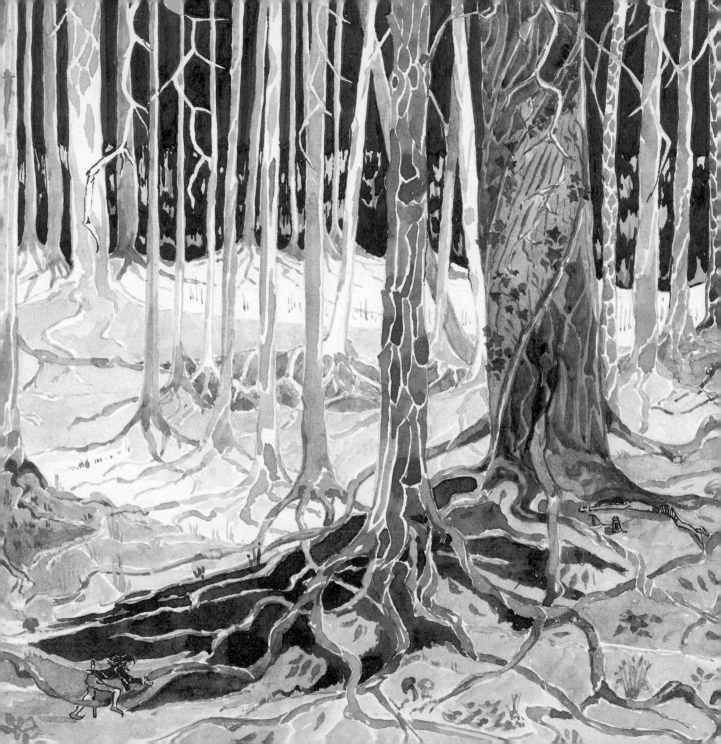

The second Silmarillion map

[1930s]

Pencil and black, green, red and blue ink

MS. Tolkien S 5/1, fols. 93–6

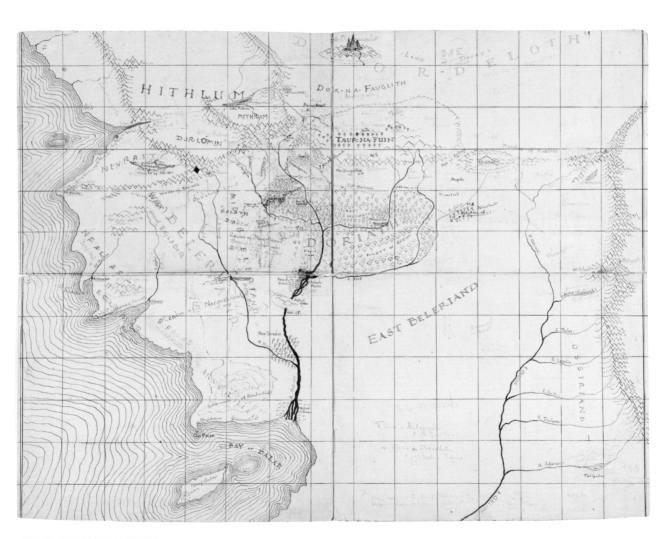

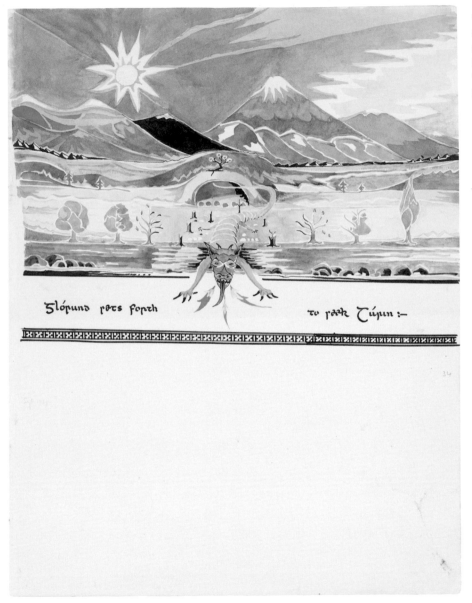

'Glórund sets forth to seek Túrin'
Glórund is one of the dragons of
Morgoth, later killed by Túrin,
September 1927
Watercolour, black ink
MS. Tolkien Drawings 87, fol. 34

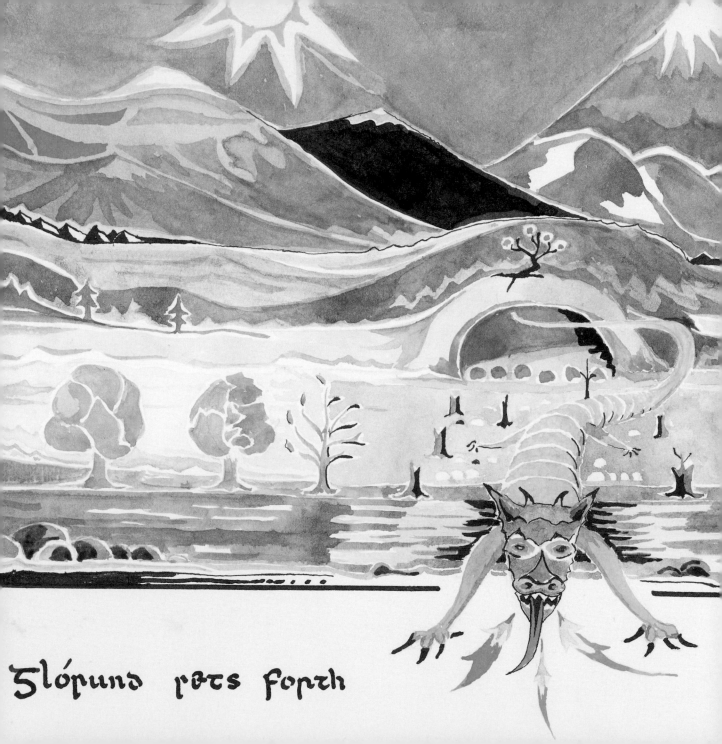

Glórund rœts forth

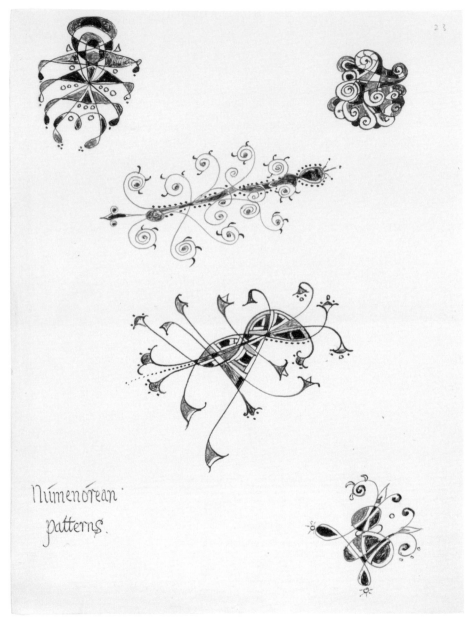

Númenórean
patterns.

'Númenórean patterns'
Designs associated with the
Númenórean civilization of the
Second Age of Middle-earth,
[1960s]
Black ink, coloured ballpoint
MS. Tolkien Drawings 91, fol. 23

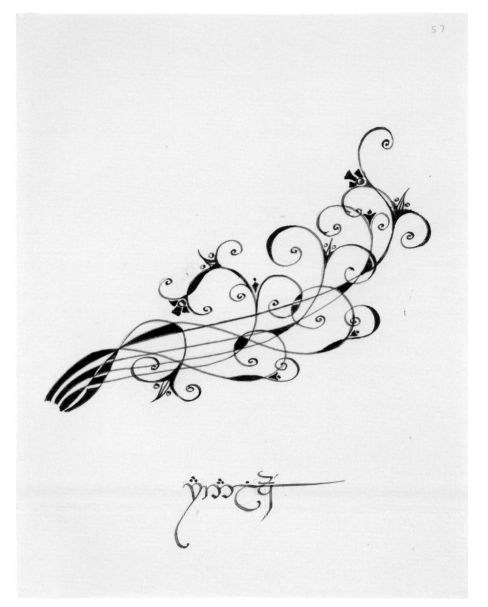

'ranalinque'
Quenya name for 'moon-grass',
[*c*.1960]
Black ink, pencil
MS. Tolkien Drawings 91, fol. 57

'Lúthien Tinúviel'
Heraldic device for the Elven princess who was inspired by Edith Tolkien, [?1960]
Watercolour, coloured pencil, black ink, pencil
MS. Tolkien Drawings 91, fol. 7

'Lúthien Tinúviel'
Second heraldic device for Lúthien,
[?1960]
Black ink, coloured pencil, pencil
MS. Tolkien Drawings 91, fol. 9

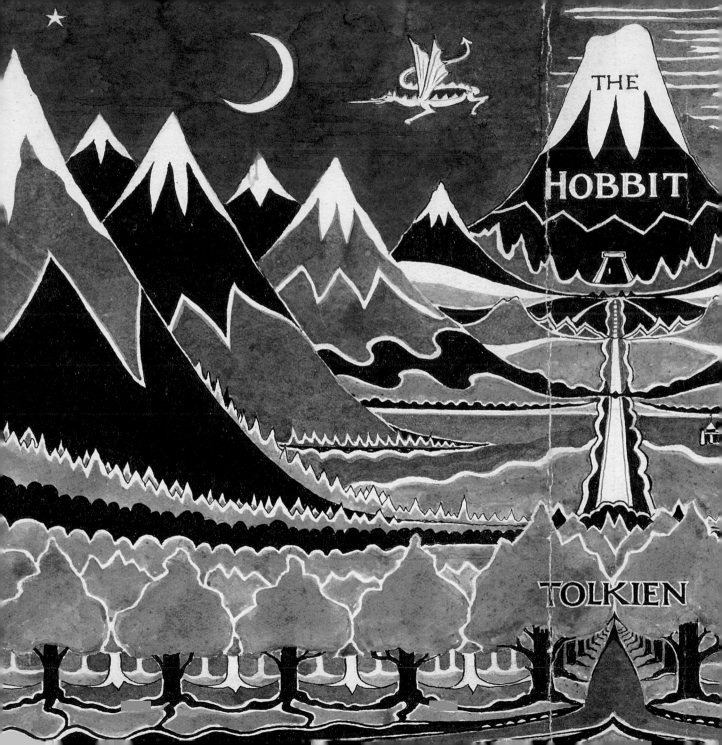

The Hobbit

'In a hole in the ground there lived a hobbit' – the now famous opening line of *The Hobbit* was written by Tolkien on a blank page in an examination paper as he was engaged in the tedious summer task of marking. He wrote the line spontaneously and many years later declared, 'I did not and do not know why.'[1] It developed into a story that he told to his three young sons and was initially a stand-alone tale, unrelated to the earlier legends of Middle-earth on which he had been working for many years. However, the pull of his unpublished legendarium proved too strong and *The Hobbit* was drawn into the world he had created for 'The Silmarillion'. It proved to be the crucial link between his Elven mythology set in a remote past, and the more familiar world of fairy tale. It includes references to the earlier legends (in the character of Elrond and the account of the Necromancer – revealed in *The Lord of the Rings* as Sauron), and is set in the same world, but Tolkien's stroke of genius was the inclusion of an entirely new race – hobbits. These comically conservative human creatures, short in stature and in imagination, allowed the readers to see the legendary world of heroes and monsters through the eyes of very ordinary people, not unlike themselves.

The book was published by George Allen & Unwin in September 1937 and was immediately hailed as a children's classic. Tolkien not only wrote the text but also illustrated the book, and designed the binding and the dust jacket. The first edition contained ten black and white illustrations and two maps. It sold out within three months and a second printing was rushed through before Christmas. This was enhanced by the addition of four beautiful watercolours, also by Tolkien, from a set of five that he had painted for the American edition. His published artwork was in fact only the tip of the iceberg. He had created sixty-one drawings and paintings, fourteen maps and plans, eight binding designs, three versions of the dust jacket design and seven facsimile texts written in runes and his Elvish script, Tengwar. His publisher was delighted with the book's success and encouraged Tolkien to write more about hobbits; a request that led directly to the composition and publication of the even more successful work, *The Lord of the Rings*.

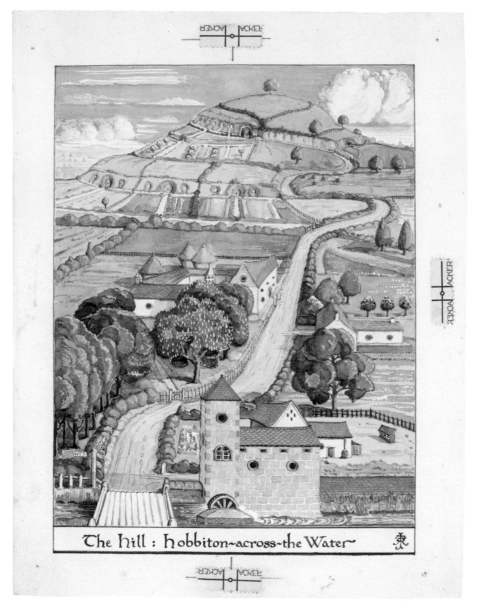

The hill : hobbiton-across-the Water

'The Hill:
Hobbiton-across-the Water'
[August 1937]
Detail shows Bag-End, with a
white bench outside Bilbo's green
front door and the hobbit holes in
Bagshot Row below.
Watercolour, white bodycolour,
black ink
MS. Tolkien Drawings 26

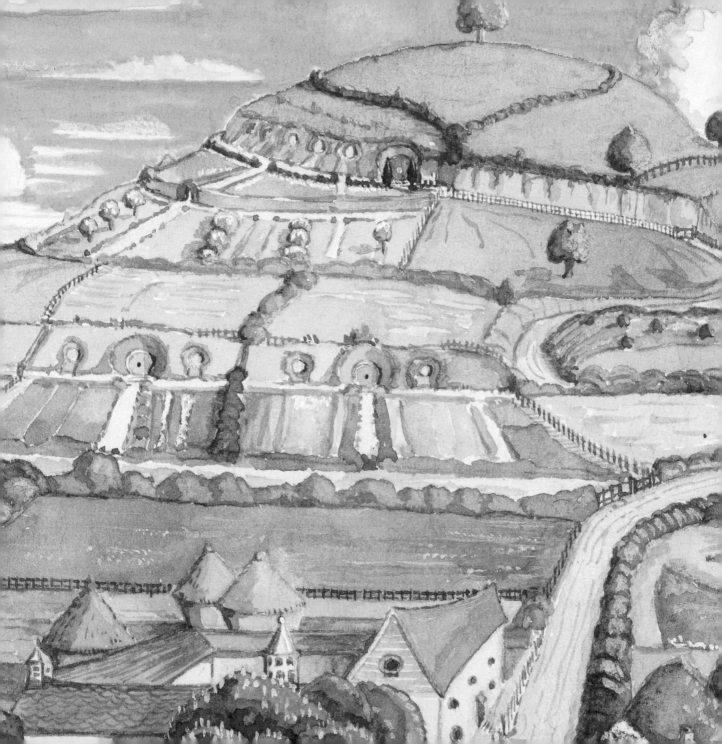

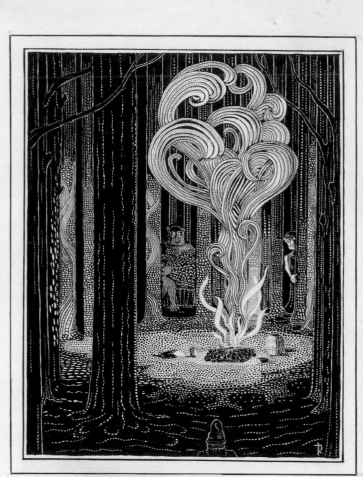

.The Trolls.

'The Trolls'
[January 1937]
Detail shows the three Trolls
waiting in the shadows to capture
the Dwarves as they approach
the fire.
Black ink, white bodycolour
MS. Tolkien Drawings 9

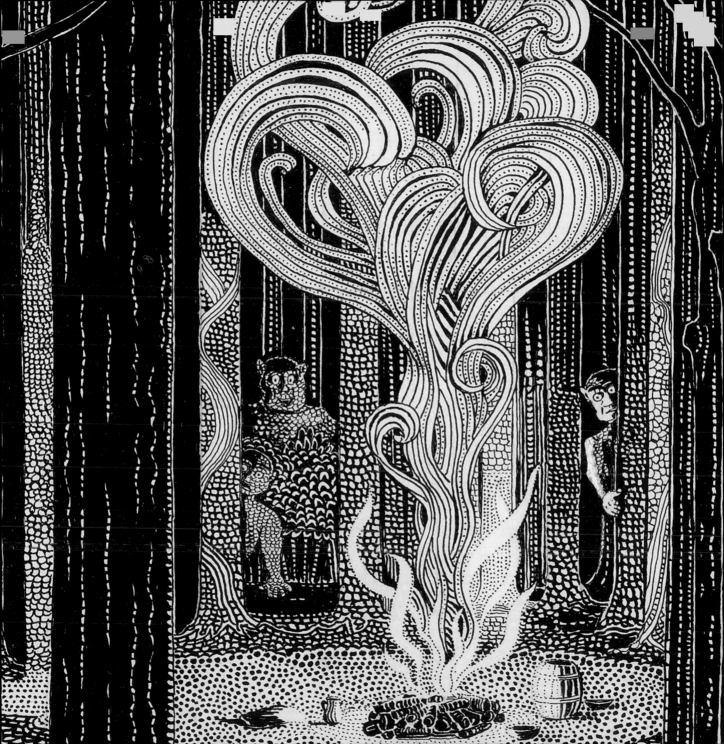

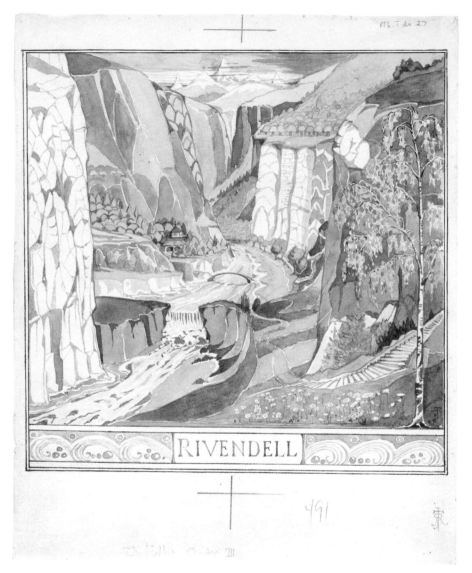

'Rivendell'
[July 1937]
Detail shows the approach to the house of Elrond, the Last Homely House.
Watercolour, black ink, pencil
MS. Tolkien Drawings 27

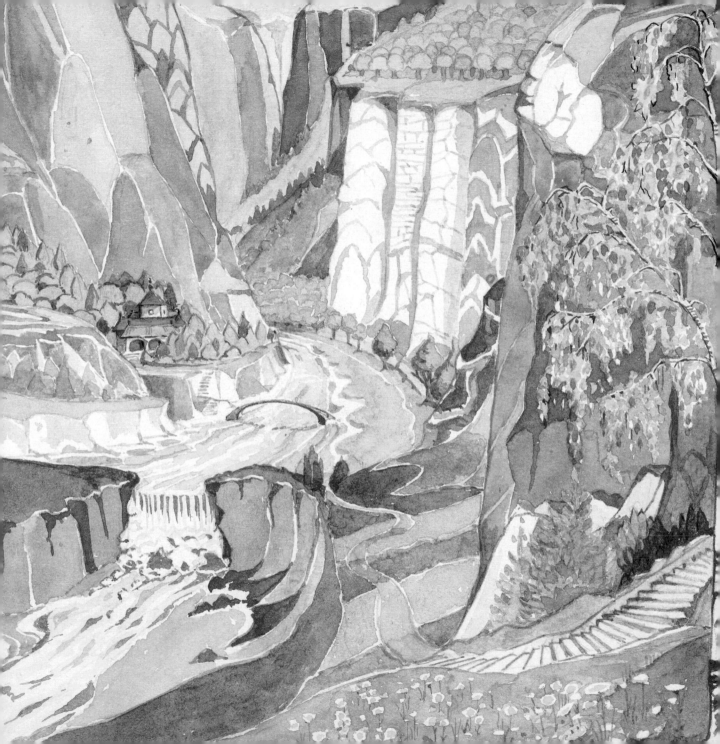

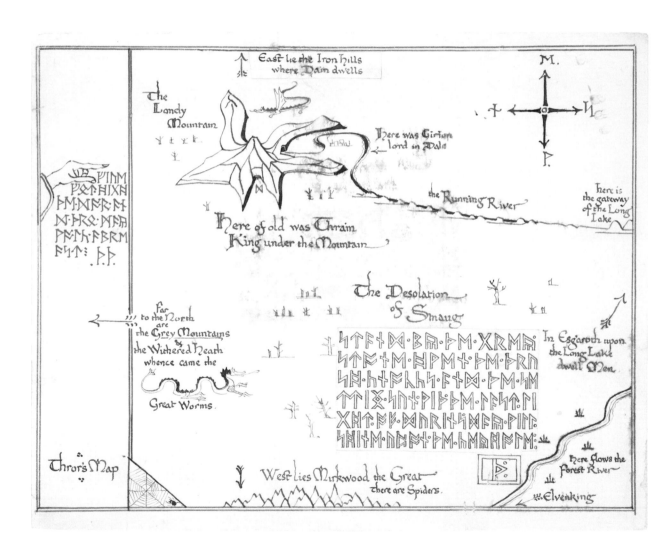

The Mountain-path

'The Mountain-path'
[January 1937]
Black ink
MS. Tolkien Drawings 13

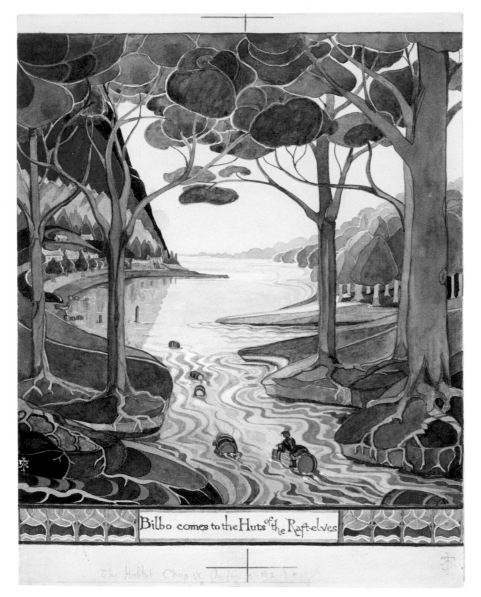

Bilbo comes to the Huts of the Raft-elves

'Bilbo comes to the Huts of the Raft-elves'
[July 1937]
Detail shows the village of the Raft-elves nestling around the sandy bay.
Watercolour, pencil, white bodycolour
MS. Tolkien Drawings 29

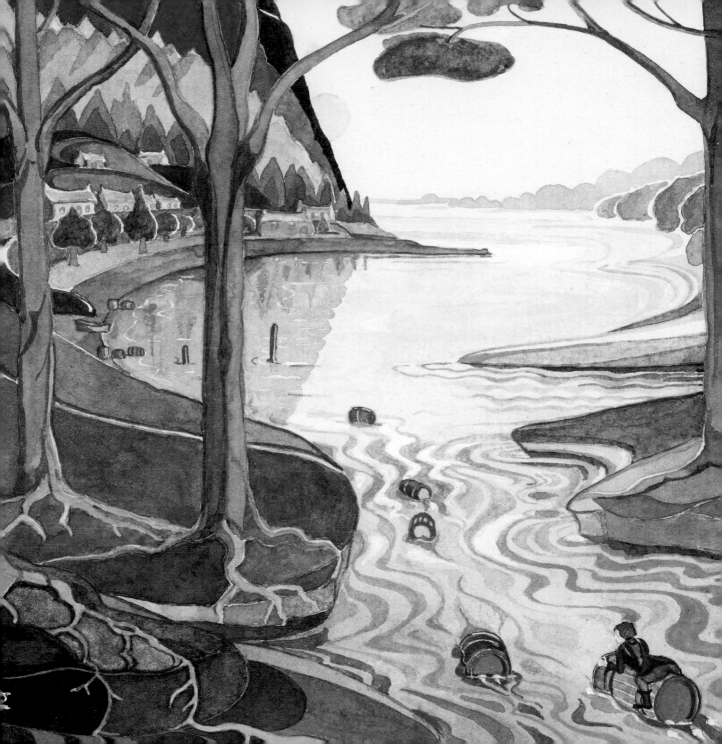

Map of 'Wilderland'

[1937]

Detail shows the Mountains
of Mirkwood and the giant
spiders who inhabit the forest.
Black and blue ink
MS. Tolkien Drawings 35

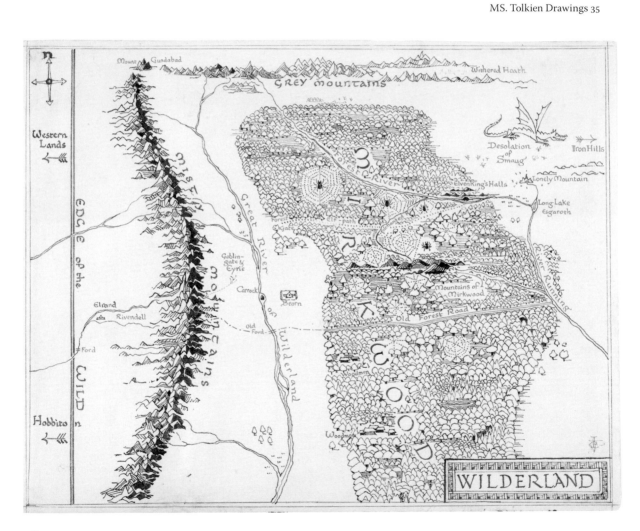

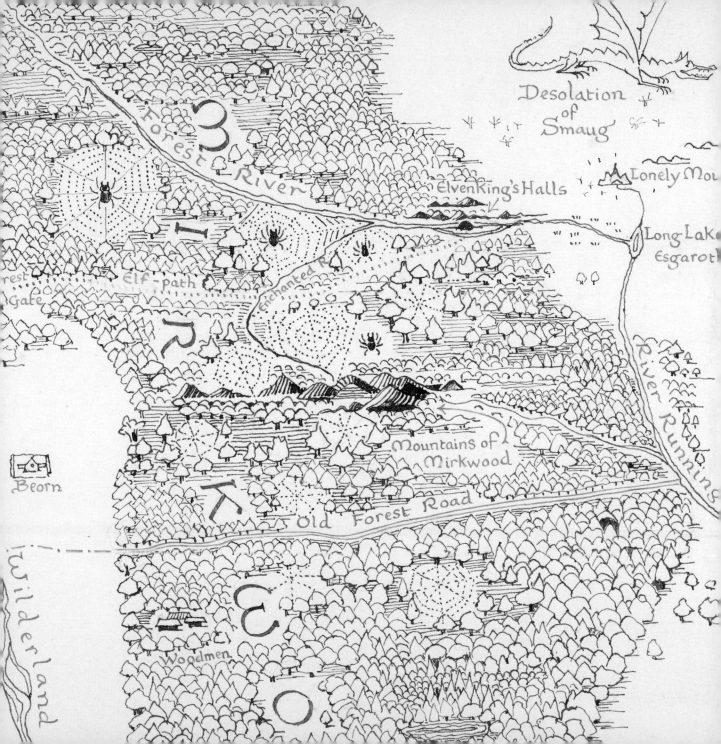

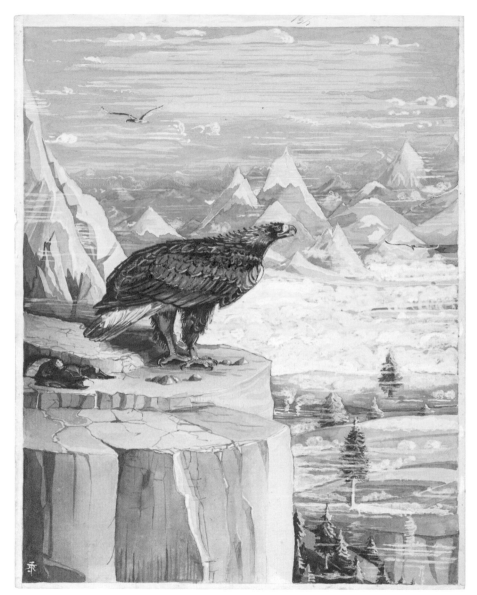

'Bilbo woke up with the early sun in his eyes'
[July 1937]
Detail shows Bilbo in the eagle's eyrie, wearing rather incongruous long black boots.
Watercolour, white bodycolour, black ink
MS. Tolkien Drawings 28

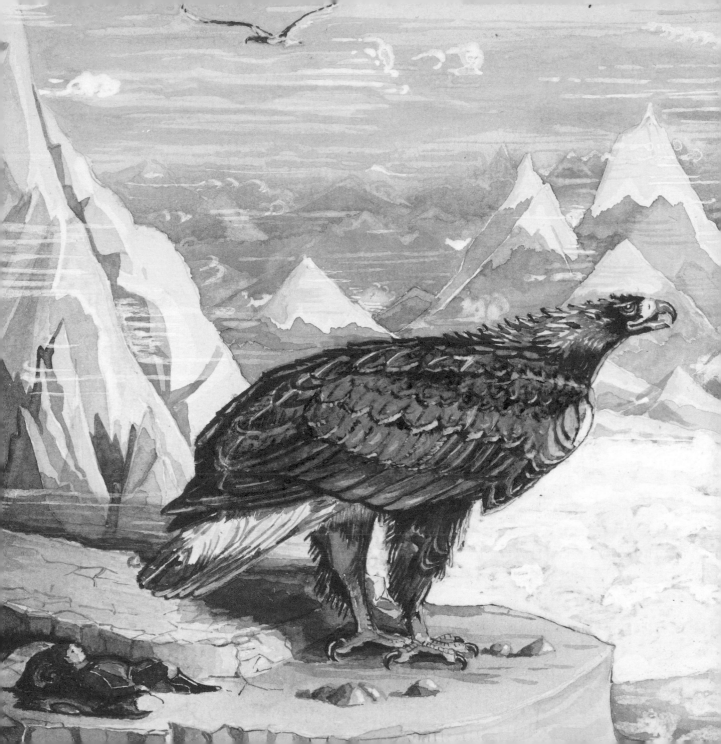

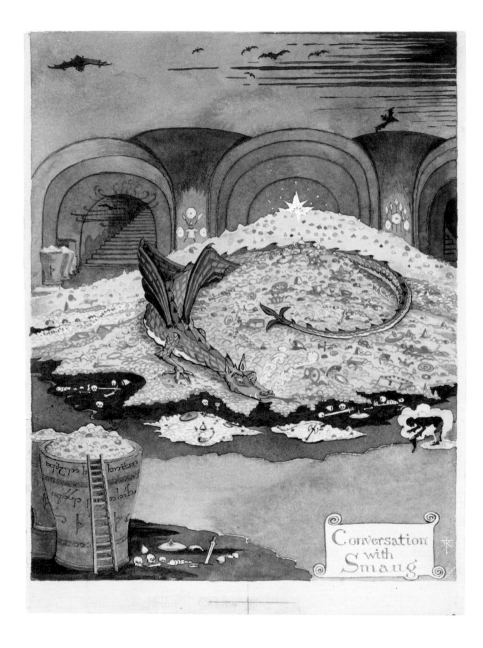

'Conversation with Smaug'
[July 1937]
Detail shows Bilbo bowing to the dragon, shielded by his ring of invisibility.
Black and coloured ink, watercolour, white body colour, pencil
MS. Tolkien Drawings 30

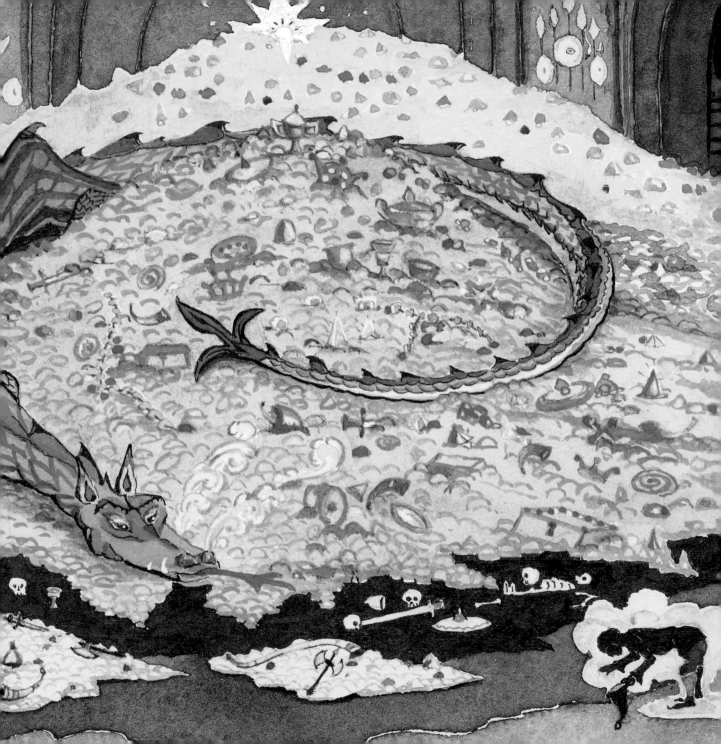

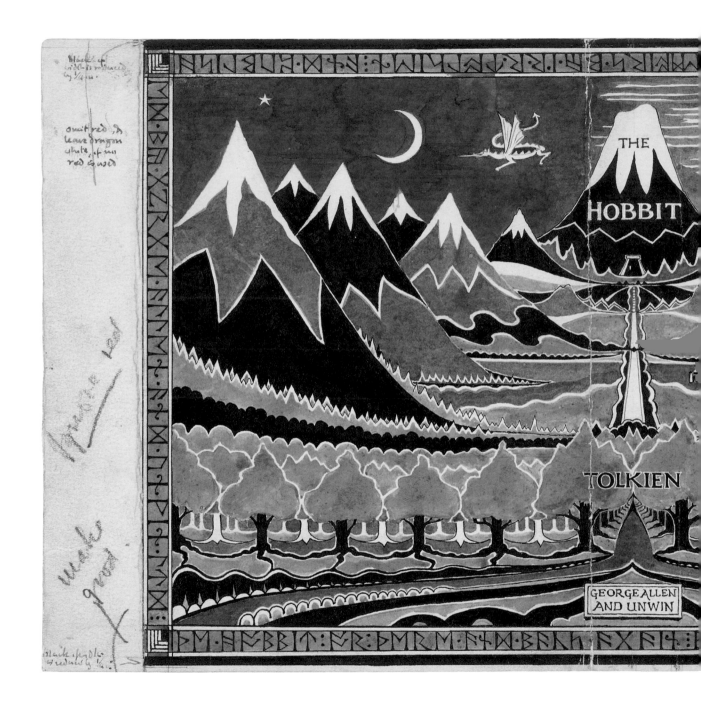

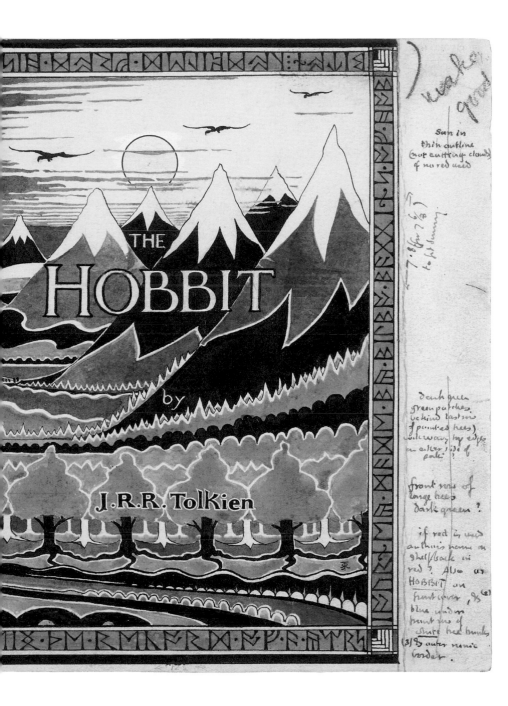

Design for the dust jacket
[April 1937]
Pencil, black ink, watercolour,
white bodycolour
MS. Tolkien Drawings 32

The Lord of the Rings

The Lord of the Rings began as a children's book, a sequel to *The Hobbit*, but during its writing it became a much longer, darker and more adult tale. In fact it became a sequel to Tolkien's vast unpublished legendarium, 'The Silmarillion', which he had been creating for over twenty years.

Tolkien worked on the 'new Hobbit', as it was initially known, for twelve years, writing late into the night, amid air-raid duties and after days filled with teaching, committee meetings, domestic chores and family concerns. During this time the Second World War started and finished, his four children grew up and left home, he sold his family house in north Oxford and moved to a college property in town and he changed his professorial chair, moving colleges in the process. He completed the book in 1949 but it was not brought to full publication until 1955 when Tolkien was close to retirement.

The book posed a number of publishing problems due to its bulk, its subject matter and its target audience. Was there any market for a long, adult, fantasy work? Rayner Unwin was convinced of its merits and his father, the head of George Allen & Unwin, gave him permission to publish it even if it entailed a loss for the firm: '*If* you believe it is a work of genius, *then* you may lose a thousand pounds.'[1] The book was published in three volumes, in 1954–5, and did not in fact lose money, selling steadily at first and gradually becoming a publishing phenomenon. Forty years after publication it was voted the book of the century, and almost fifty years after publication it was voted Britain's favourite book.[2] The book was never envisaged as an illustrated work but Tolkien, for whom art and literature were closely connected, made numerous illustrations as he wrote the text. The drawings in coloured pencil, using a muted palette, were part of his creative process and an aid to the visualization of scenes and landscapes. He also created facsimile documents and designed a number of striking dust jackets for each volume. These items *were* intended for publication and incorporated the invented scripts and languages that were central to his legendarium. Unfortunately, most were not included owing to cost.

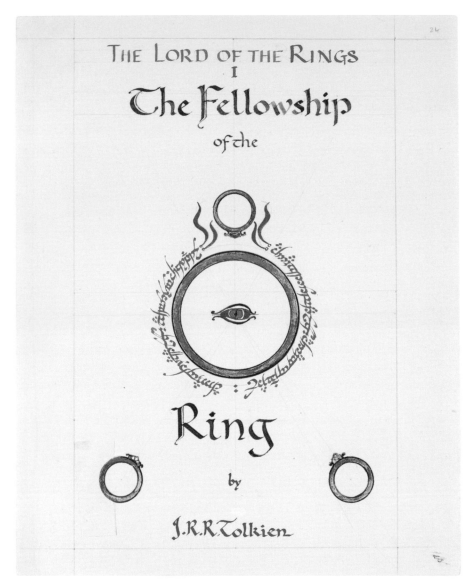

THE LORD OF THE RINGS
I
The Fellowship
of the

Ring

by

J.R.R. Tolkien

Dust jacket design for *The Fellowship of the Ring*
[March 1954]
The design features the Eye of Sauron within the One Ring, opposed by the three Elven rings. The fire-writing around the ring reads, 'One Ring to rule them all, One Ring to find them, One Ring to bring them all and in the darkness bind them.'
Red and black ink, gold paint, pencil, coloured pencil
MS. Tolkien Drawings 90, fol. 24

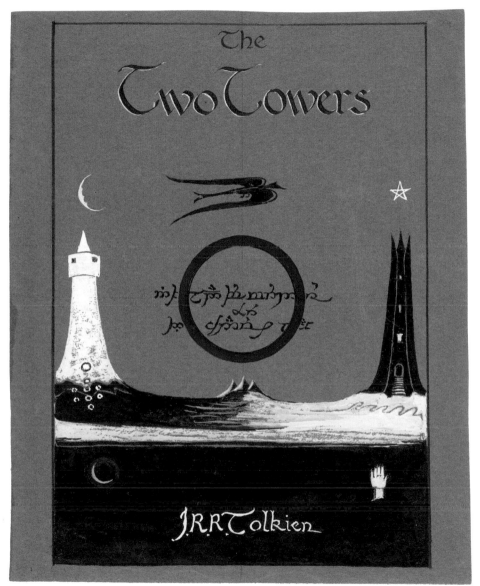

Dust jacket design for *The Two Towers*
[March 1954]
The design features the white tower of Minas Morgul and the black tower of Orthanc. Watercolour, white bodycolour, black ink, pencil MS. Tolkien Drawings 90, fol. 29r

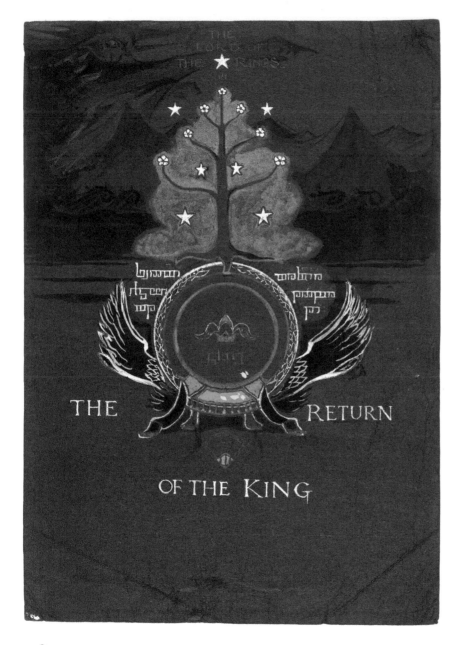

The Fire-writing
Versions, in different styles, of
the inscription which appears
on the One Ring when it is
subjected to fire, [1953]
Red and black ink, pencil
MS. Tolkien Drawings 90, fol. 39r

'Old Man Willow'
The face of Old Man Willow
can be seen on the upper part
of the trunk, [?1938]
Pencil, coloured pencil
MS. Tolkien Drawings 71

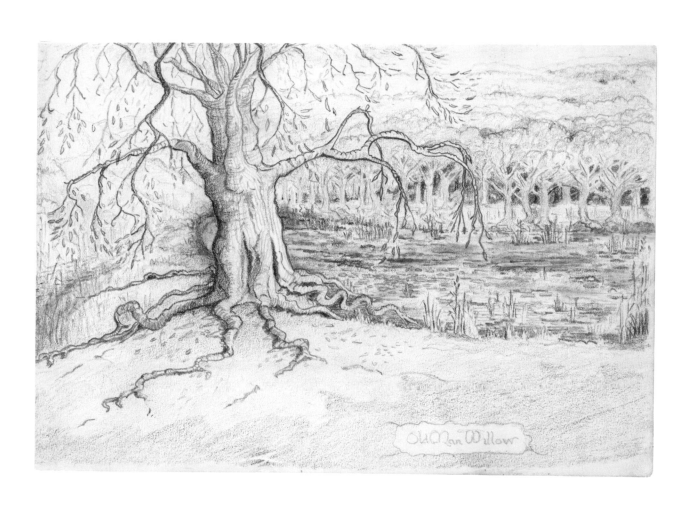

Old Man Willow

'Moria Gate'
[?1939]
Pencil, coloured pencil
below **Lower**: MS. Tolkien
Drawings 89, fol. 15r
opposite **Upper**: MS. Tolkien
Drawings 72

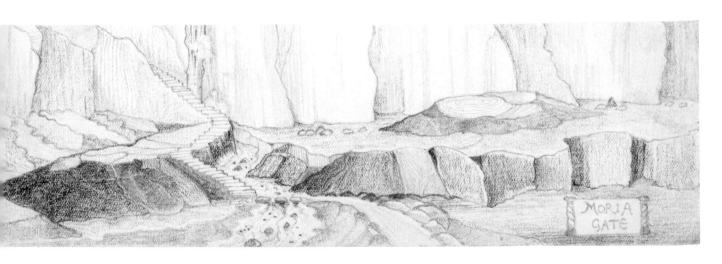

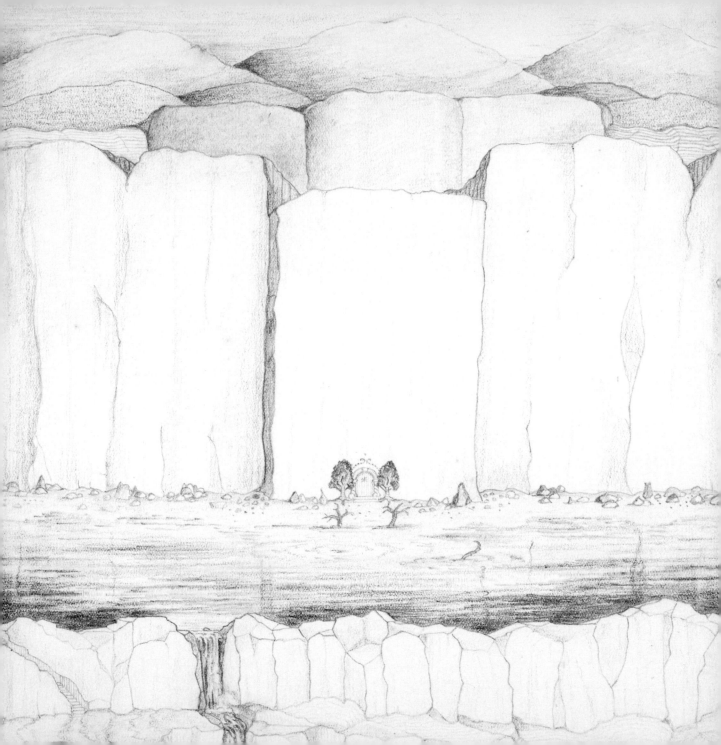

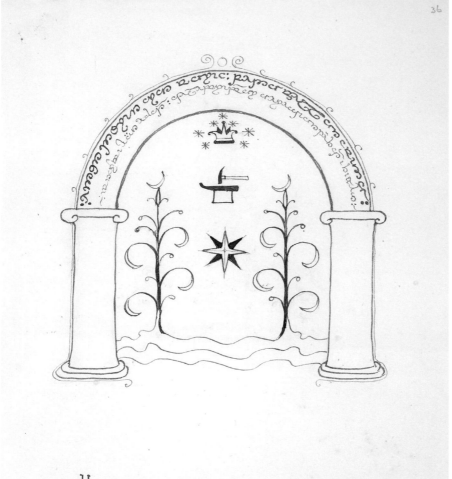

Here is written in an archaic form of the Elvish characters:
Ennyn Durin Aran Moria: pedo mhellon
a minno.
Im Narvi hain echant: Celebrimbor o Eregion
teithant i thiw hin.

The Doors of Durin
The inscription over the archway includes the Elvish words, 'Speak Friend and Enter', a clue to the password which will open the doors, [1953]
Blue ink, pencil
MS. Tolkien Drawings 90, fol. 36r

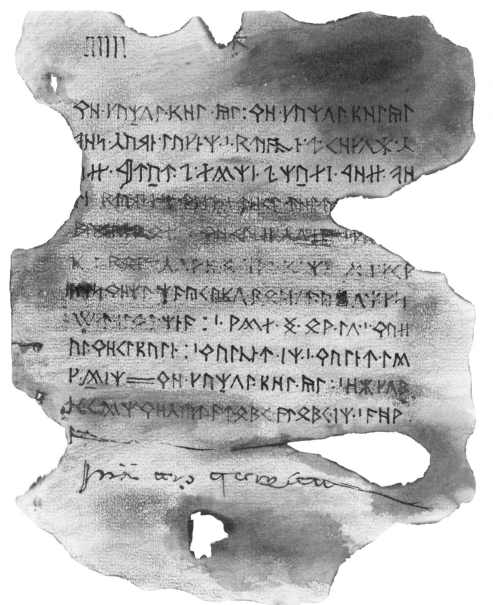

Final page from the Book of Mazarbul, found in the Mines of Moria
One of three facsimile pages created by Tolkien, [1940s]
Black ink and watercolour on yellow paper
MS. Tolkien Drawings 75

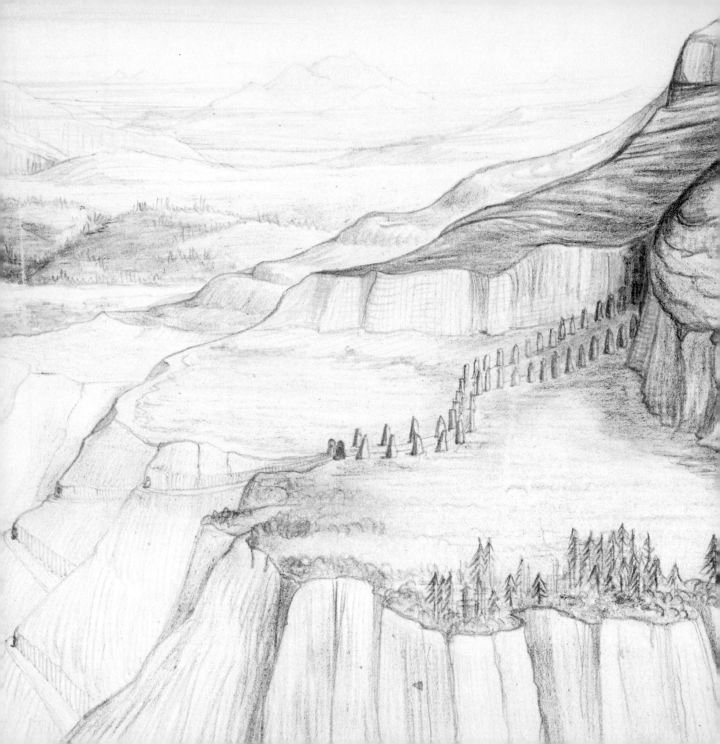

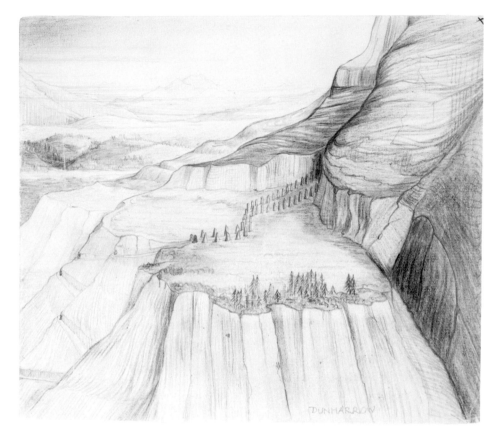

'Dunharrow'
[?1944]
Detail shows the double line
of standing stones leading
into the Hold of Dunharrow,
an early conception of the
mountain stronghold.
Pencil, coloured pencil
MS. Tolkien Drawings 79

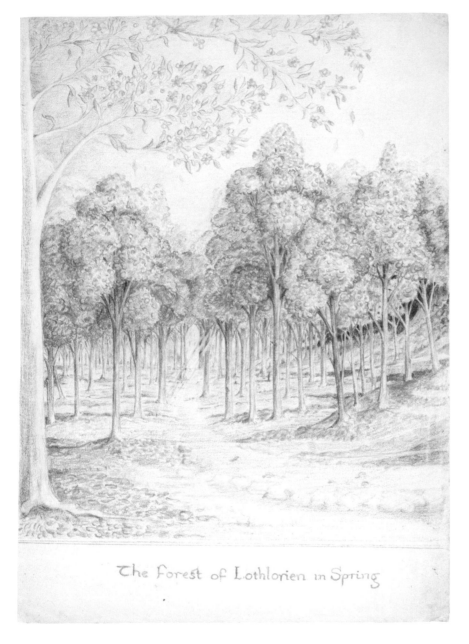

The Forest of Lothlorien in Spring

'The Forest of Lothlorien in Spring'
[early 1940s]
Pencil, coloured pencil
MS. Tolkien Drawings 89, fol. 12

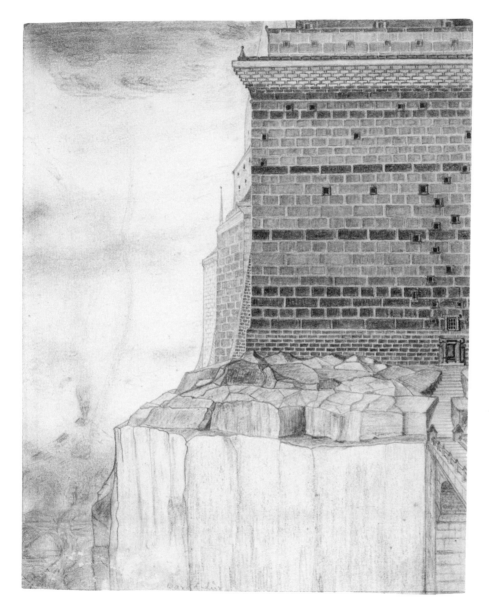

'Barad-dûr: The Fortress of Sauron'
[*c*.1944]
Pencil, coloured pencil, black ink
MS. Tolkien Drawings 80

Mapping Middle-earth

Maps were an essential part of Tolkien's world-building. While his creation started with the invention of languages, languages required 'people' to speak them, people required places to live and places required maps. His legendarium covers a large geographical area, from the frozen seas in the north to the desert lands of the south, and from the Dwarf kingdoms in the east to the Blessed Realm beyond the western sea. These vast distances needed mapping.

Tolkien created maps from an early stage in his writing. They gave shape to his imagined world and created a believable reality. Within this world the stories unfolded. An early notebook, dating from 1918–20, in which he wrote *The Book of Lost Tales* (the forerunner of *The Silmarillion*), contains a diagram of the world, showing part of Middle-earth and part of the Land of the Gods. Further diagrams and maps followed as the tales burgeoned and the geography of Middle-earth expanded. When he began to write *The Hobbit* in the late 1920s, one of the first things he did was to draw Thror's map, the treasure map that lies at the heart of the story which leads the Dwarves and Bilbo Baggins to the dragon's lair.

The Lord of the Rings was more heavily mapped than any of his other works. Tolkien confided, 'I wisely started with a map, and made the story fit'.[1] There are thirty maps in the Bodleian Archive relating solely to this book. Some are rough sketches, such as the first map of the Shire. Others are detailed depictions of the whole arena of action. The maps which follow are a selection of those created as he wrote *The Lord of the Rings*.

The great distances travelled and the detailed descriptions of each part of the journey given in the text required similarly detailed charts to ensure accuracy and consistency. The scale was also of paramount importance. In order to be believable, each day's journey had to be within the capabilities of the traveller, whether he was a sturdy man of Gondor or a young hobbit of half human stature. Tolkien was proud of the fact that he 'never made anyone go farther than he could on a given day.'[2] It was this attention to detail that ensured the reader remained immersed in the 'reality' of Middle-earth.

The first map of the Shire
[1938]
Detail shows the land either side
of the Brandywine river, with
the ferry crossing marked with a
double line, and the entrance to the
Old Forest marked in red.
Pencil, blue and red ink
MS. Tolkien Drawings 104r

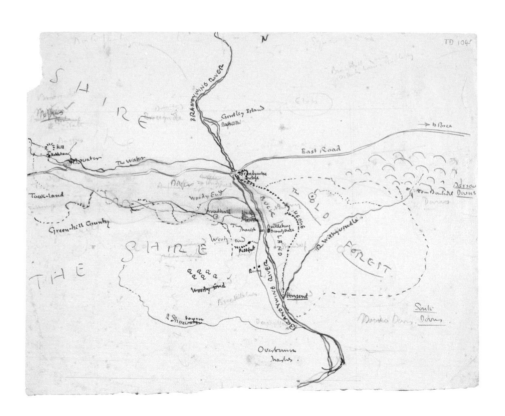

S H I R E

S H I R E

H E

BRANDYWINE RIVER

Elvs

Girdley Island
Buck bl.

East Road

Hill
Hobbiton
Byewater
The Water

Bracegirdle

Brandywine
Bridge

Woody End

BUCK

The
Newbury

OLD

Woodhall

Marish

Woody end

Bucklebury
Brandyhall

LAND

R. Withywindle

Greenhill County

Woody End

Passfort

Ferry

BRANDYWINE RIVER

Haysend

R. Shirewater
bourn

Dingle Hill Glen

Deephallow

Overbourn
Marshes.

'Genesis of "Lord of the Rings"'
Notes written on the back of the
first map of the Shire, [1938]
Pencil, black and blue ink
MS. Tolkien Drawings 104v

124 TOLKIEN TREASURES

Map of the north-west of Middle-earth
[*c*.1948]
Blue and red ink, pencil, coloured pencil
MS. Tolkien Drawings 124

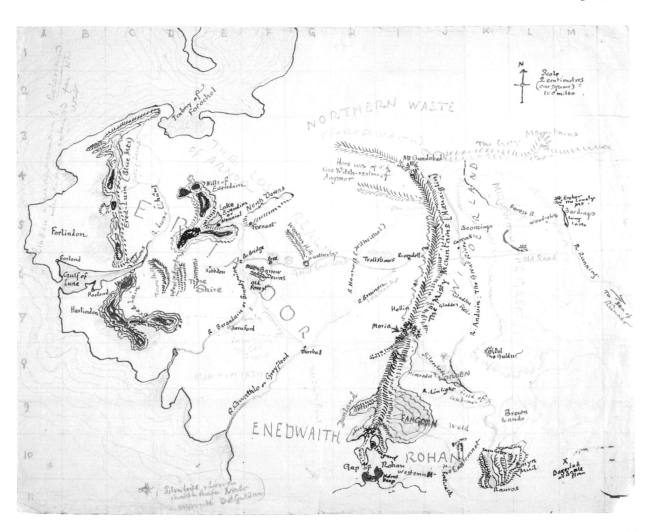

Map of the south-west of Middle-earth
[c.1948]
Blue, black and red ink, coloured pencil, pencil
MS. Tolkien Drawings 125

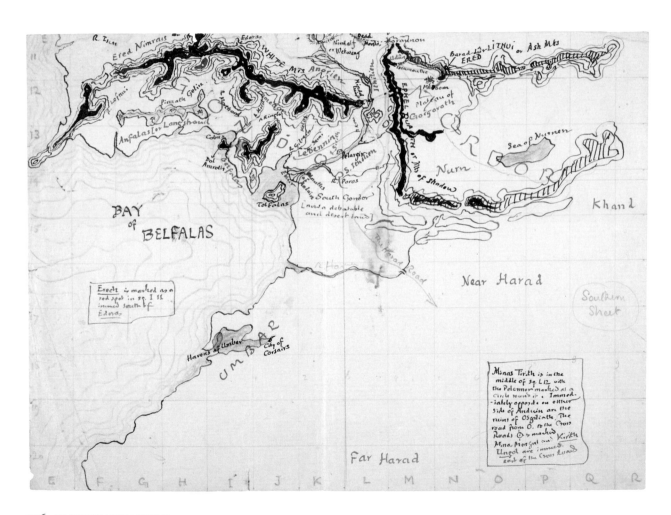

Ered [...]

WHITE

Mts Anorien

Ivetwang

Udûn

Bara E

Iscamouthe

Mt. Doom

Plateau of Gorgoroth

EPHEL DUA[...]

[...]th or Mts of Shadow

Nurn

Lefnui

Pinnath Gelin

R. Morthond

R. Lameron

R. Kiril

R. Ringlo

R. Gilrain

Lebennin

R. Serni

R. Sirith

R. Erui

Jethilien

Anfalas or Langstrand

Cobas

Belfalas

Dol Amroth

Tolfalas

Ethir

Pelargir

N. Ithilien

R. Poros

Harnen

Menlitos

Anduin

South Gondor

[now a debatable and desert land]

BAY of BELFALAS

Erech is marked as a red spot in sq. I 11 immed south of Edoras

The Harad Road

R. Harn[...]

UMBAR

Havens of Umbar

City of Corsairs

U M B A R

Far Harad

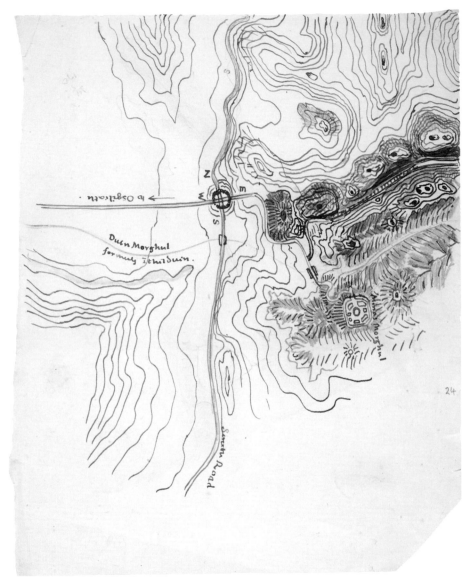

Map of Minas Morghul and the cross-roads
[May 1944]
Detail shows the tower of Minas Morghul (later spelled Morgul) and the polluted stream of Duin Morghul which flows out of the vale.
Black ink, pencil, coloured pencil
MS. Tolkien Drawings 127r

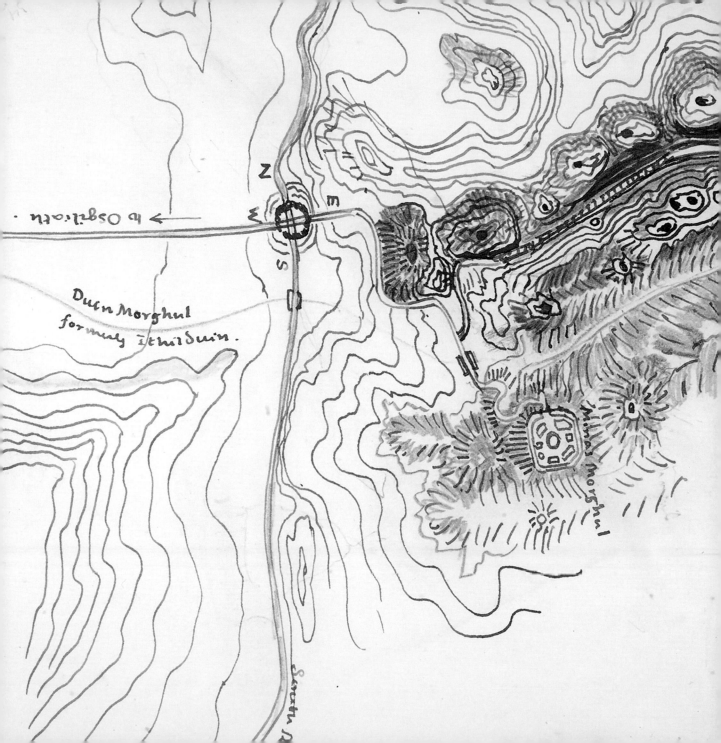

to Osgiliath ←

N
W E
S

Dún Morghul
formerly Ithilduin.

Minas Morghul

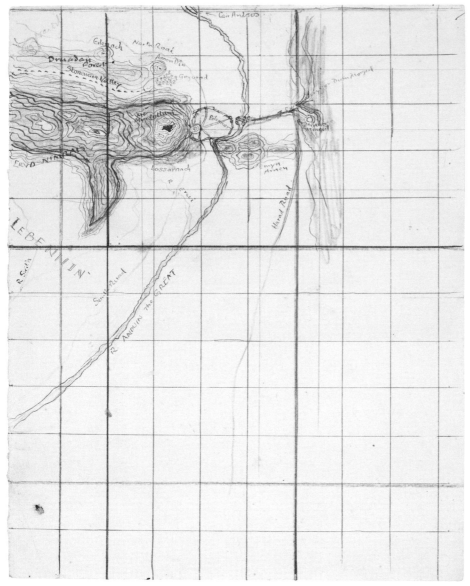

Map of the eastern end of the White Mountains
[*c.*1946]
Blue ink, coloured pencil, pencil
MS. Tolkien Drawings 122r

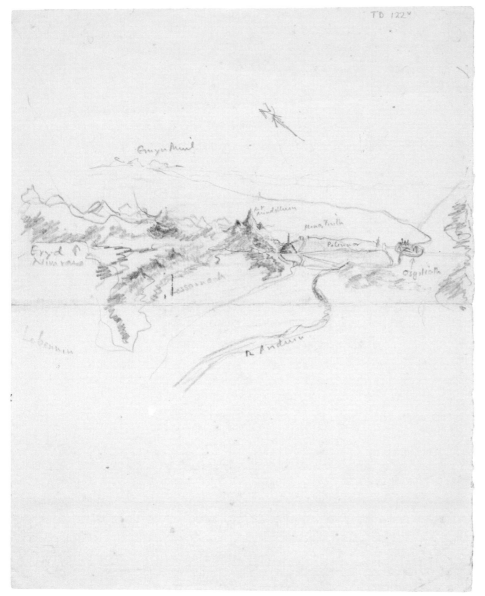

TD 122ᵛ

Bird's eye view of the eastern end of the White Mountains
[*c.*1946]
Pencil, coloured pencil, black ink
MS. Tolkien Drawings 122v

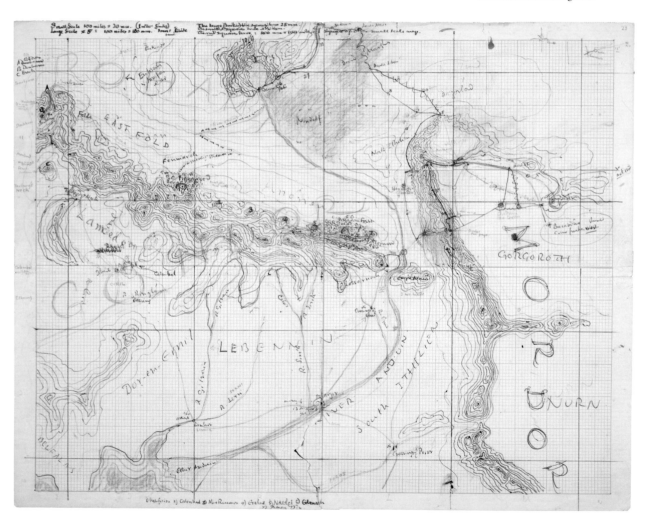

Map of Rohan, Gondor and Mordor
[*c*.1948]
Pencil, blue and red ink and
coloured pencil, on graph paper
MS. Tolkien Drawings 126

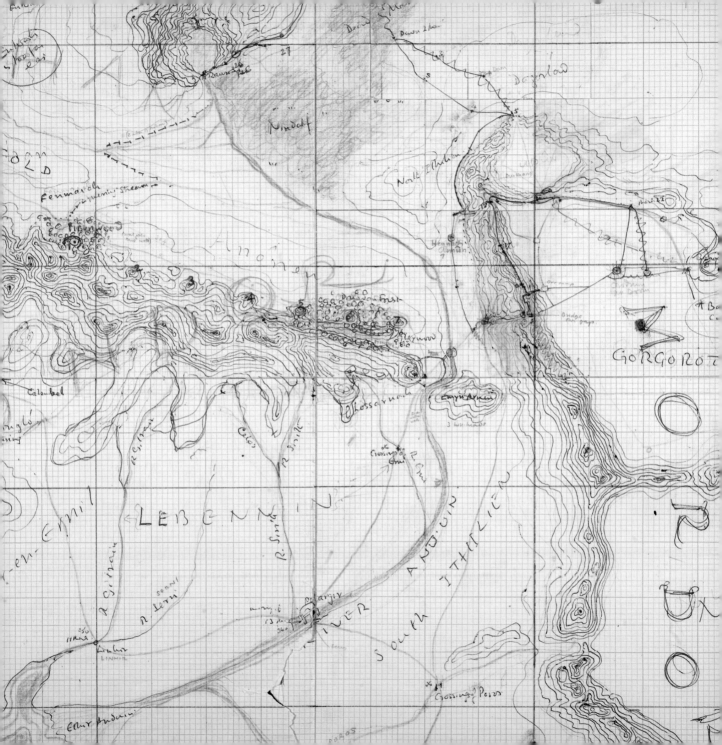

Working map of Rohan, Gondor and Mordor, in use during the writing of Book V
[*c*.1946]
Black, blue and red ink, pencil, coloured pencil
MS. Tolkien Drawings 123

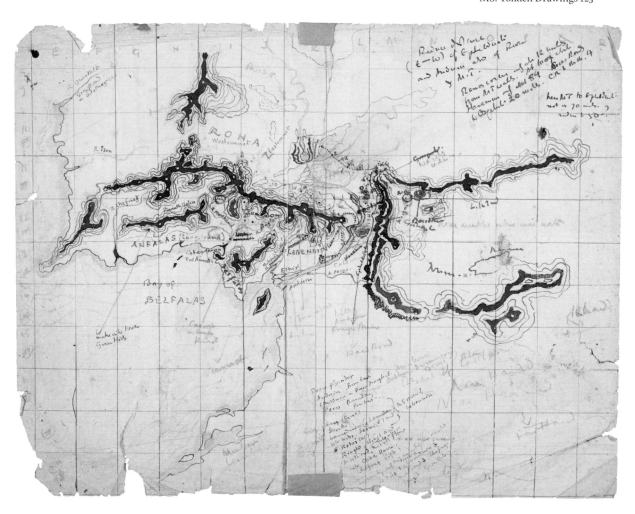

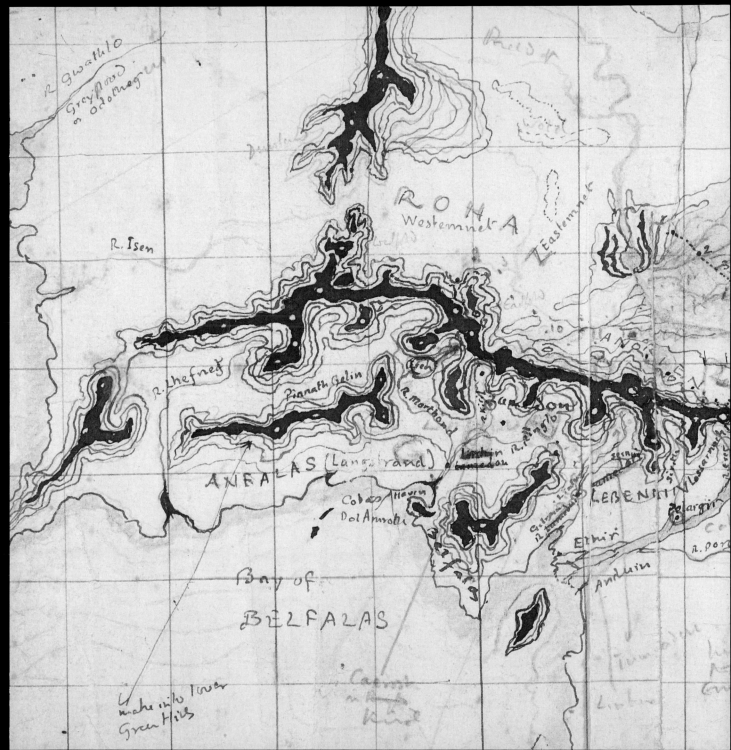

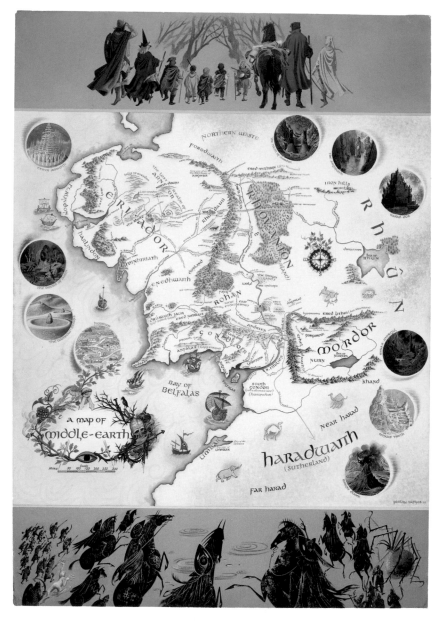

Pauline Baynes, 'A Map of Middle-earth'
Original artwork for the poster map of Middle-earth, 1969 Detail shows vignette of Minas Morgul which Tolkien admired as being almost exactly like his own conception.
Watercolour, pencil
MS. Tolkien Drawings 100

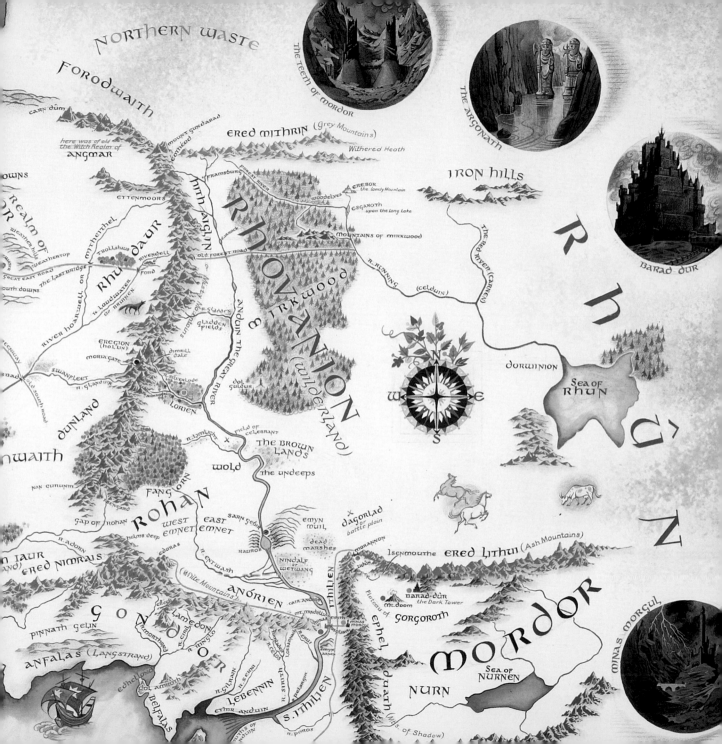

NORTHERN WASTE

FORODWAITH

The teeth of mordor

The argonath

carn dûm

here was of old
the Witch Realm of
ANGMAR

mount gundabad

ERED MITHRIN (grey Mountains)

Withered Heath

IRON HILLS

Barad-dûr

OWNS

REALM OF

weather hills

weathertop

ETTENMOORS

TROLLSHAWS

R. hoarwell or mitheithel

RHUDAUR

RIVENDELL

Ford

FRAMSBURG

FOREST RIVER

woodelves

EREBOR
the Lonely Mountain

ESGAROTH
upon the Long Lake

MOUNTAINS OF MIRKWOOD

R. RUNNING

THE RED RIVER (CARNEN)

R
h
ū
n

Great East Road

the Last Bridge

south downs

RIVER hoarwell or bruinen

R. Loudwater
or bruinen

EREGION
(hollin)

MORIA GATE

hithaeglin

OLD FOREST ROAD

carrock

RHOVANION

carrock

(celduin)

greenway

SWANFLEET

R. GLANDUIN

old south road

R. SILVERLODE

R. GLADDEN

gladden
fields

dimrill
dale

MIRKWOOD

ANDUIN THE GREAT RIVER

(WILDERLAND)

DORWINION

Sea of
RHUN

DUNLAND

nwaith

NAN CURUNIR

FANGORN

LORIEN

R. LIMLIGHT

dol
guldur

field of
celebrant

THE BROWN
LANDS

WOLD

the undeeps

ROHAN

GAP OF ROHAN

helms deep

WEST
EMNET

EAST
EMNET

SARN GEBIR

EMYN
MUIL

dagorlad
or battle plain

DEAD
MARSHES

N IAUR
AND)

ERED NIMRAIS

edoras

R. ADORN

R. ENTWASH

NAUROS

NINDALF
or WETWANG

MORANNON

ÛDÛN

Isenmouthe

ERED LITHUI (Ash Mountains)

GONDOR

White Mountains

ANÓRIEN

cair andros

ITHILIEN

Plateau of
GORGOROTH

Mt.doom

Barad-dûr
the Dark Tower

MORDOR

MINAS MORGUL

PINNATH GELIN

LAMEDON

ANFALAS (LANGSTRAND)

edhellond

dol amroth

LEBENNIN

S.ITHILIEN

EPHEL DUATH (hills of Shadow)

Sea of
NURNEN

NURN

BELFALAS

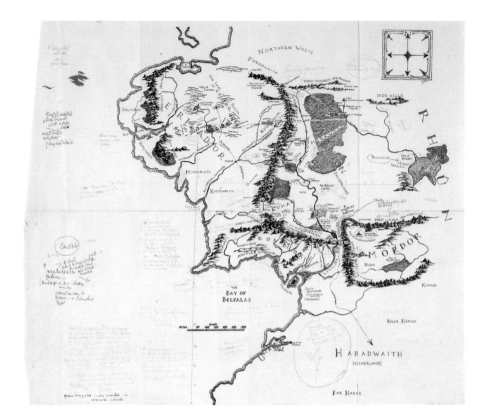

Printed map of Middle-earth
Annotated by Tolkien (in green ink, pencil and black ink) and Pauline Baynes (in blue ink and pencil), from which Baynes produced the poster map of Middle-earth, [1969]
MS. Tolkien Drawings 132

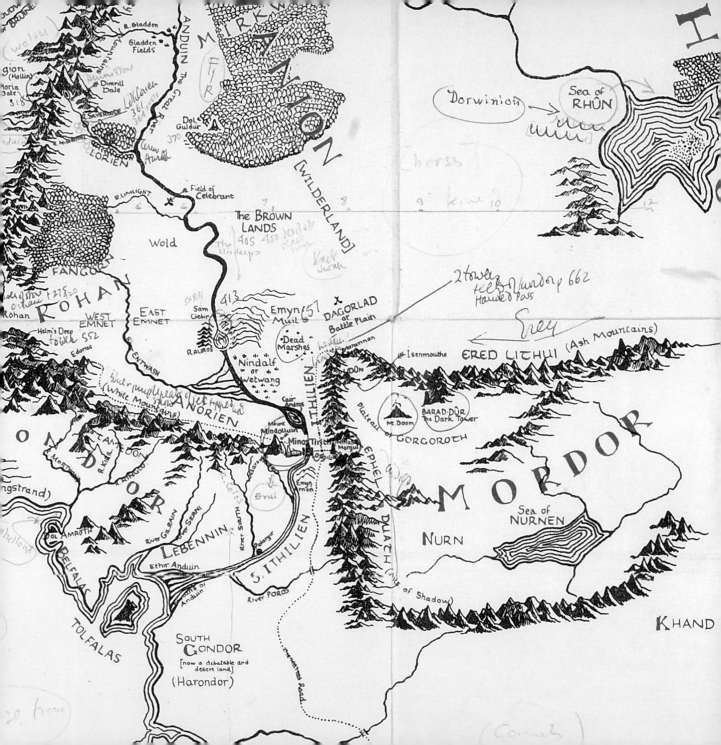

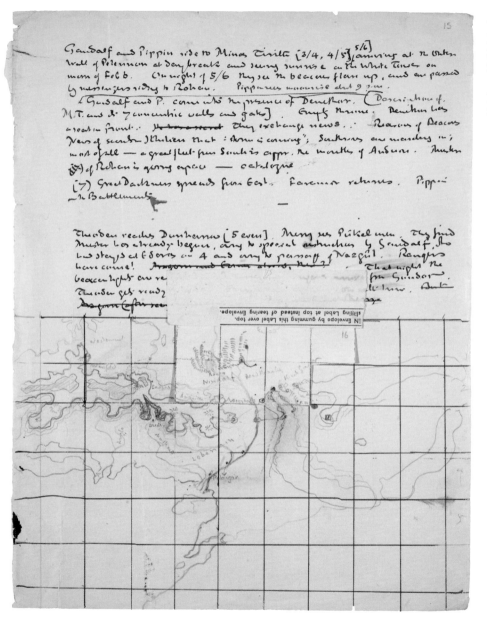

Gandalf and Pippin ride to Minas Tirith [3/4, 4/5, 5/6] arriving at the Outer Wall of Pelennor at day break and seeing sunrise on the White Tower on morn of Feb 6. On night of 5/6 they see the beacons flare up, and are passed by messengers riding to Rohan. Pippin sees mounted out 9 a.m.

< Gandalf and P. come into the presence of Denethor. (Description of M.T. and its 7 concentric walls and gates) Guard rooms. Denethor has a road in front. ~~the~~ They exchange news. . . Rumour of Beacons News of scouts IIkhilien that : "them is coming"; Darkness are mending in ; most of all — a great fleet from South is appr. the mouths of Anduin. Muster of Rohan is going apace — catalogue

(7) Great Darkness spreads from East. Faramir returns. Pippin — the Battlements.

Theoden reaches Dunharrow [5 even]. Merry see Pukel-men. They find Muster has already begun, owing to special instruction by Gandalf. He has stepped ed forces in 4 and owing to passage of Nazgul. Rangers have come! ~~Aragorn and Eomer strive, they ?~~. That night the beacon lights are re from Gondor. Theoden gets ready ~~Dawn Gask~~ see

16

'Gandalf and Pippin ride to Minas Tirith'
Plot notes for the beginning of Book V with sketch map,
[October 1944]
Black ink, pencil, coloured pencil
MSS. Tolkien Drawings 118–19

Notes

Where dates are given in square brackets this indicates that the date is not given on the manuscript but is definite, unless preceded by a question mark or '*c.*' References to 'The Silmarillion' refer to the unpublished work, unless specified.

INTRODUCTION

1 Carpenter and Tolkien 1981, p. 219.
2 Carpenter and Tolkien 1981, p. 214.
3 Tolkien family papers, note on letter from A. Shepherdson, [1964].
4 Hooper 2000–6, p. 1049.
5 Carpenter and Tolkien 1981, p. 184.
6 Hooper 2000–6, p. 1049.
7 Carpenter and Tolkien 1981, p. 417.
8 Carpenter and Tolkien 1981, p. 420.
9 Carpenter and Tolkien 1981, p. 333.
10 Tolkien 1964.

SCHOLAR AND AUTHOR

1 Tolkien 2001, p. 94.

THE SILMARILLION

1 Carpenter and Tolkien 1981, p. 143.
2 Plimmer and Plimmer 1968; Carpenter and Tolkien 1981, p. 219.

THE HOBBIT

1 Carpenter and Tolkien 1981, p. 215.

THE LORD OF THE RINGS

1 Unwin 1999, p. 99.
2 'Book of the Century', poll of 25,000 readers by Waterstones, 1997; the BBC's Big Read, a poll to find the nation's favourite book, 2003.

MAPPING MIDDLE-EARTH

1 Carpenter and Tolkien 1981, p. 177.
2 Plimmer and Plimmer 1968.

Further Reading

CARPENTER 1977: H. Carpenter, *J.R.R. Tolkien: A Biography*, George Allen & Unwin, London, 1977

CARPENTER AND TOLKIEN 1981: *The Letters of J.R.R. Tolkien*, ed. H. Carpenter and C.R. Tolkien, George Allen & Unwin, London, 1981

HAMMOND AND SCULL 1995: W.G. Hammond and C. Scull, *J.R.R. Tolkien: Artist and Illustrator*, HarperCollins, London, 1995

HAMMOND AND SCULL 2011: W.G. Hammond and C. Scull, *The Art of The Hobbit by J.R.R. Tolkien*, HarperCollins, London, 2011

HAMMOND AND SCULL 2015: W.G. Hammond and C. Scull, *The Art of The Lord of the Rings by J.R.R. Tolkien*, HarperCollins, London, 2015

HOOPER 2000–6: *The Collected Letters of C.S. Lewis*, ed. W. Hooper, 3 vols, HarperCollins, London, 2000–6

OXFORD 1992: J. Priestman, *J.R.R. Tolkien: Life and Legend: An Exhibition to Commemorate the Centenary of the Birth of J.R.R. Tolkien (1892–1973)*, exh. cat., Bodleian Library, Oxford, 1992

PLIMMER AND PLIMMER 1968: C. Plimmer and D. Plimmer, 'The man who understands hobbits', *The Daily Telegraph*, 22 March 1968

SCULL AND HAMMOND 1998: J.R.R. Tolkien, *Roverandom*, ed. C. Scull and W.G. Hammond, HarperCollins, London, 1998

SCULL AND HAMMOND 2006: C. Scull and W.G. Hammond, *The J.R.R. Tolkien Companion and Guide*, 2 vols, HarperCollins, London, 2006

TOLKIEN 1937: J.R.R. Tolkien, *The Hobbit*, George Allen & Unwin, London, 1937

TOLKIEN 1954–5: J.R.R. Tolkien, *The Lord of the Rings*, 3 vols, George Allen & Unwin, London, 1954–5

TOLKIEN 1964: J.R.R. Tolkien, audio interview by Denys Gueroult, BBC, 1964

TOLKIEN 1976: J.R.R. Tolkien, *The Father Christmas Letters*, ed. B. Tolkien, George Allen & Unwin, London, 1976 (and later eds)

TOLKIEN 1977: J.R.R. Tolkien, *The Silmarillion*, ed. C.R. Tolkien, George Allen & Unwin, London, 1977

TOLKIEN 1979: J.R.R. Tolkien, *Pictures by J.R.R. Tolkien*, ed. C.R. Tolkien, George Allen & Unwin, London, 1979

TOLKIEN 1980: J.R.R. Tolkien, *Unfinished Tales of Númenor and Middle-earth*, ed. C.R. Tolkien, George Allen & Unwin, London, 1980

TOLKIEN 1983–96: *The History of Middle-earth*, 12 vols, ed. C.R. Tolkien, 1983–96

TOLKIEN 2001: J.R.R. Tolkien, *Tree and Leaf, Including Mythopoeia and The Homecoming of Beorhtnoth*, HarperCollins, London, 2001

TOLKIEN 2014: J.R.R. Tolkien, *Beowulf: A Translation and Commentary*, ed. C.R. Tolkien, HarperCollins, London, 2014

TOLKIEN AND TOLKIEN 1992: J. Tolkien and P. Tolkien, *The Tolkien Family Album*, HarperCollins, London, 1992

UNWIN 1999: R. Unwin, *George Allen & Unwin: A Remembrancer*, Merlin Unwin Books, Ludlow, 1999

Index

Page numbers in *italics* refer to illustrations.